Exploring the
ORIGINAL
West Village

Exploring *the* ORIGINAL
West Village

Alfred Pommer & Eleanor Winters

Charleston — London

THE
History
PRESS

Published by The History Press
Charleston, SC 29403
www.historypress.net

Cover image: Abingdon Square *by Leendert van der Pool*.

All internal images courtesy of Alfred Pommer unless otherwise noted.
All maps are courtesy of Eleanor Winters.

First published 2011
Manufactured in the United States
ISBN 978.1.60949.151.2

Library of Congress Cataloging-in-Publication Data

Pommer, Alfred.
Exploring the original West Village / Alfred Pommer and Eleanor Winters.
p. cm.
ISBN 978-1-60949-151-2
1. West Village (New York, N.Y.)--History. 2. New York (N.Y.)--History. 3. City and town
life--New York (State)--New York--History. 4. Historic sites--New York (State)--New York.
5. Historic buildings--New York (State)--New York. 6. West Village (New York, N.Y.)--
Buildings, structures, etc. 7. New York (N.Y.)--Buildings, structures, etc. 8. West Village
(New York, N.Y.)--Biography. 9. New York (N.Y.)--Biography. I. Winters, Eleanor. II. Title.
F128.68.W48P65 2011
974.7'1--dc22
2011013396

This book is dedicated to Joyce Pommer and Bob and Beth Cooperman, with love.

Contents

Contents

Acknowledgments

The authors would like to express their gratitude to the authors of the excellent *AIA Guide to New York City*—Norval White, Elliot Willensky and Fran Leadon—for their invaluable compendium of New York City architecture. We would also like to thank Dr. Hans Krabbendam of the Roosevelt Study Center in the Netherlands and Robert Cooperman, poet and grammarian, for their generous assistance with the text. We also wish to thank David Carter, author of *Stonewall: The Riots that Sparked the Gay Revolution*, for permission to quote him in our book.

INTRODUCTION

New York City is the dream destination of millions of tourists from around the world. To say that countless guidebooks have been published for over two hundred years—since the dawn of modern tourism in the mid-eighteenth century—doesn't begin to describe the mountains of literature available on every aspect of our enchanting city: its architecture, history, restaurants, music, theater, shopping—the list goes on and on. And today, with the vast resources of the Internet, there is no way to calculate how many billions of words have been written about New York City.

So what can we offer that is special? We are about to take you on a short walk through a tiny area of Manhattan. Just as Google Earth whirls us into an ever smaller focus, starting from outer space and ending up at your home address (almost looking in your window), we will take you to New York City, to Manhattan Island, to the famous—and sometimes infamous—Greenwich Village and then within Greenwich Village to the Original West Village, a small neighborhood crammed with famous names and locations, streets, parks and buildings that evoke the magic of New York's colorful past.

Is it a walking tour? Well, not exactly. We propose that you let us do the walking. Sit back in your comfortable chair while we regale you with tales of the city, the people and events that have given Greenwich Village its world-renowned reputation as "a place apart." While totally integrated

into the current life and past history of New York City, the Village remains somehow different, outside the "Manhattan Grid" of numbered streets and avenues that make the rest of Manhattan so easy to navigate.

Can a New Yorker get lost in the West Village? Oh yes. Greenwich Village is a neighborhood whose streets intersect at crazy angles; where named streets alternate with numbered streets; where, famously, West Fourth Street crosses West Tenth, Eleventh and Twelfth Streets; where there is a Greenwich Street running parallel (more or less) to Greenwich Avenue; and a park that can be reached only by climbing a long stairway to an elevated structure once covered with (still visible) railroad tracks.

But what exactly is the Original West Village? It is a roughly trapezoidal area, bounded on the north by Fourteenth Street, on the south by Christopher Street, on the east by Greenwich Avenue and on the west by the Hudson River. It comprises the northwest portion of Greenwich Village, which extends farther south (as far as Houston Street) and quite a bit farther east. The eastern boundary of the West Village is Avenue of the Americas, but Greenwich Village these days also includes two areas

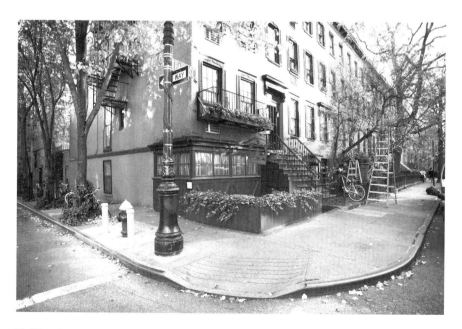

Ye Waverly Inn, the corner of Bank and Waverly Streets.

to the east, one historically known as the Central Village or Washington Square, and another neighborhood, informally known as the East Village.

The actual borders of Greenwich Village tend to vary depending on which map you look at. One can easily be confused by the numerous designations: the West Village, Central Village, South Village, East Village, Greenwich Village Historic District and more!

But, as we said, our focus is smaller. We'll tell you about the South Village (between Christopher and Houston Streets) and the East Village another time.

As we stroll through the streets of the Original West Village and tell you some of its stories, you will probably notice that we tend to digress from time to time. History is never linear. One tale inevitably leads to another, and as our stories unfold, we'll find ourselves wandering off now and again, following threads that lead us far afield. But that's the fun of it. We'll try to keep to our topic, but we can't promise anything!

Chapter 1

DEVELOPMENT OF GREENWICH VILLAGE

A Little Background

As the name implies, Greenwich Village was once a country hamlet, a rural village located two miles north of the original seventeenth-century Manhattan settlement. Before the acquisition of Manhattan by the Dutch in 1609, the area we call Greenwich Village was a Lenape Indian village known as Sapokanikan, meaning "Tobacco Field." (It is interesting to note that the Lenape language is responsible for the name "Manhattan," a Dutch representation of "Manna-Hata," as mentioned in the logbook of Henry Hudson's voyage of discovery on the *Half Moon*.)

And indeed tobacco was cultivated there. In 1629, Wouter Van Twiller, a clerk working for the Dutch West India Company and who later served as director of New Amsterdam (between 1633 and 1638), was granted the rights to two hundred acres located at and around what is now Gansevoort Street, where he established a tobacco farm. Gansevoort Street, by the way, was named for Peter Gansevoort, an American Revolutionary War general and grandfather of Herman Melville.

The Dutch called this corner of Manhattan "Noortwijck," or "Noortwyck," meaning Northern District, a name that was soon changed to "Groenwijck," Green District, probably due to its pastoral beauty. With the transfer of ownership of Manhattan Island to the English in 1664, the name Groenwijck was Anglicized and became "Greenwich." And so it has remained.

Our earliest Greenwich Village luminary was Sir Peter Warren, a wealthy landowner and colorful figure, whose acquaintance we will make in Chapter 7. Sir Peter acquired three hundred acres of farmland in 1733, extending east from Hudson Street to Fifth Avenue and south from Twenty-first Street to Third Street, a vast amount of land indeed, at least by contemporary New York City standards!

Greenwich Village in the eighteenth century remained rural and scenic but also became a refuge for city dwellers escaping the frequent cholera, smallpox and yellow fever epidemics. Fleeing the crowded, insalubrious conditions of the city, New Yorkers went north to Greenwich Village. Many remained there, slowly increasing the population of this once remote hamlet, which achieved village status in 1712. Sir Peter Warren's very large house, which occupied a city block on today's map (from Bleecker Street to West Fourth Street, Charles Street to Perry Street), was spacious enough to accommodate the entire New York Assembly in 1739, when smallpox drove them from the city.

By the end of the eighteenth century, many businesses had moved north, including the Bank of New York, whose original office was—and still is—on Wall Street. The bank responded to a yellow fever epidemic in 1798 by purchasing eight lots in Greenwich Village and opening offices in this safer location, which is where the name of Bank Street originated. Bank Street runs east to west, from one end of the Original West Village to the other. Quite a lot transpired on Bank Street in subsequent years—more on that later.

The nineteenth century brought great changes to the Original West Village. As the neighborhood became increasingly residential, its inhabitants began exerting their political muscle. Newgate Prison, the first prison established in New York and the second in the United States, built in 1796, was no longer welcome in the neighborhood. It was moved upstate to Ossining (Sing-Sing) in 1829.

Public transportation improved. A ferry service across the Hudson River between Weehawken, New Jersey, and the foot of Christopher Street, initiated unofficially in 1812, was purchased by the Hoboken Land Improvement Company in 1833. Originally established to carry produce from New Jersey farms to New York markets (the Weehawken Market, which opened in 1828, was served by these ferries), by 1870, six million passengers per year were using the ferries to cross the Hudson.

Piers were located both at Christopher Street and, farther south, at Barclay Street.

In the nineteenth century, the development of the Original West Village was very different from the area around Washington Square. By the 1830s, Washington Square was a fashionable neighborhood of Greek Revival townhouses and upper- and upper-middle-class American-born Protestant families.

The character and population of the Original West Village was a world away from that of Washington Square. From the mid-nineteenth century until well into the twentieth, the Original West Village was the destination of large numbers of immigrants from Ireland, Italy, Poland and Germany. The income level was much lower than that of Washington Square and the spoken language was not always English.

The winding streets west of Sixth Avenue had many working-class homes and tenements. Throughout the Original West Village, row houses, apartment buildings, commercial and public buildings stood—and many still do—side by side with factories and warehouses, creating an eclectic architectural mix. A largely Catholic neighborhood, numerous churches were established, including St. Veronica's on Christopher Street, which we'll hear more about in Chapter 2. At the turn of the last century, the Village was the largest Catholic archdiocese in the United States.

This population was served by an enhanced transportation system, notably the Ninth Avenue Elevated Railway, which opened in 1867, and ran from the bottom of Manhattan all the way up to 30th Street, later extending as far north as 155th Street in Harlem. The "El" made it easy for immigrant families to live near each other, and near their own churches, shops and markets, but work elsewhere in Manhattan.

The elevated railroad was not the only public transportation that served the Original West Village population. By 1828, a street railroad (the New York and Harlem Railroad), running on metal tracks, carried passengers in horse-drawn cars with metal wheels. And by the mid-1850s, hundreds of omnibuses, also pulled by horses, ran along numerous Manhattan routes, as did street-level railways, including one along Eighth Avenue.

And in 1873, a horse-drawn trolley was established, running from the East River at Greenpoint Ferry (which carried passengers between the cities of New York and Brooklyn) to Hoboken Ferry Pier. The trolley route ran along the full length of Christopher Street, from Sixth Avenue

to the Hudson docks. Until 1936, when city buses replaced the trolleys, as many as forty-six streetcars per hour ran along this route!

There were, by the way, more than ten beer and billiard saloons on Christopher Street in 1879.

Although the character of the Original West Village changed during the nineteenth century, the street plan did not. A few names were changed, but the wildly irregular layout of the streets remained. (One still asks why Little West Twelfth Street is three blocks north of West Twelfth Street? And why is West Tenth Street three blocks south of West Eleventh? And so forth.)

The preservation of the original layout of these streets is due to the Village residents' protests against the Commissioners' Plan of 1811, which organized Manhattan streets into a grid pattern, known as the Manhattan Grid. The plan was created at the behest of the Common Council—later known as the City Council—of New York City, which requested aid from New York State for planning future streets, with "a free and abundant circulation of air." The council appointed Gouverneur Morris, John Rutherford and surveyor Simeon deWitt as commissioners of streets and roads, and they in turn appointed surveyors, the chief of whom was John Randel Jr. The Commissioners' Plan is sometimes referred to as "Randel's Plan."

The plan, calling for a rectilinear grid, was designed to begin at Houston Street, the southern border of the Original West Village. A huge campaign, mounted by Clement Clarke Moore of *The Night Before Christmas* fame (which, incidentally, he may not have written—a dispute rages!), succeeded in pushing the southern boundary of the Manhattan Grid to Fourteenth Street, the northern border of Greenwich Village, thus preserving the integrity of the Village street plan. Interestingly enough, by so doing, Moore made his fortune. As owner of land in the West 20s of Manhattan, he was able to divide his property into the twenty-five- by one-hundred-foot lots designated by Randel's Plan, sell the lots as individual land parcels and make quite a lot of money.

The fortunes of the Original West Village rose and fell as the years passed; the early twentieth century saw the Village decline, which was followed, by midcentury, with increasing affluence (and eventually impossibly inflated property values).

Development of Greenwich Village

The history of the Original West Village during the early 1900s is well known; a small-scale, congenial and relatively cheap neighborhood, the Village attracted artists and writers, politicians and radicals, musicians and actors. At once a hotbed of political activity, it was also the home of the avant-garde and the latest developments in art, jazz, and modern theater.

Today, with trendy (and costly) new shops, renovated and newly built luxury housing, world-renowned restaurants and clubs, the Original West Village has become a landmark district, protected by the New York City Landmarks Preservation Commission and divided into several designated areas, including the Greenwich Village Waterfront and Meatpacking District, the Weehawken Street Historic District and the Far West Village.

But the tree-lined streets and historic buildings retain their charm and mystery, and every street has its stories.

Let's begin our walk on Christopher Street, along the southern boundary of the Original West Village.

Chapter 2

CHRISTOPHER STREET, THE NINTH AVENUE EL AND THE STORY OF WILLIAM "BILL THE BUTCHER" POOLE

Here we are on the corner of Greenwich and Christopher Streets. Greenwich Street runs right through the Original West Village, from its northern boundary on Fourteenth Street, down to Christopher Street and continues south. And Christopher Street is that iconic street that, to so many New Yorkers, represents Greenwich Village. So this is a perfect place to start.

Christopher Street, by the way, was named in 1799 in honor of Charles Christopher Amos, heir to Sir Peter Warren. Prior to 1799, the street was called Skinner Road, after Sir Peter's son-in-law, William Skinner.

Standing on the corner of Greenwich and Christopher, we are at the location of New York's first elevated railway, the Ninth Avenue El line, built between 1867 and 1879, dismantled and demolished in 1940.

The story of the Ninth Avenue El began long before 1867. As far back as 1825, traffic congestion in Manhattan was already a problem, and plans were afoot to improve public transportation. After more than forty years of deliberation, the city approved a plan for an elevated railroad line, called the West Side and Yonkers Patent Railway, to be built along Greenwich Street. Trains ran on a single track powered by steam engines located beneath the sidewalk. The engines turned huge wheels that pulled a cable that was attached to the bottom of the train, pulling the trains along the track.

An unsuccessful venture, the railroad was sold at auction in 1870 for $960, after which the stationary engines were replaced by steam

Christopher Street, the Ninth Avenue El and the Story of William "Bill the Butcher" Poole

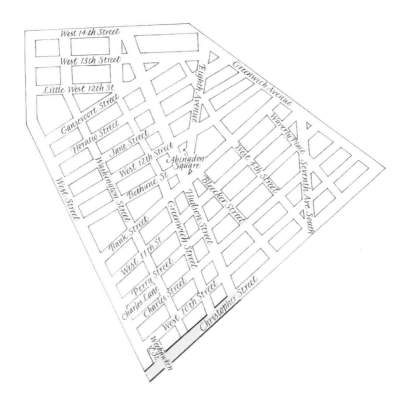

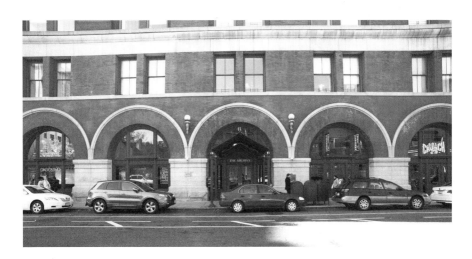

Federal Archives Building, located at the original site of Ninth Avenue El.

locomotives. With new owners and a new name—the New York Elevated Railroad Company—the Ninth Avenue El grew and expanded, converting to electric power in 1902. The Ninth Avenue El was followed by three additional elevated train lines, running along Second, Third and Sixth Avenues.

Hard as it may be to imagine, the El station at Christopher and Greenwich Streets, designed by a Swiss draftsman, was built in the style of a chalet! The train cars were praised for their efficiency and décor, which included mahogany paneling, leather seats and carpeting.

During the heyday of the Ninth Avenue Elevated trains, other advances in train transportation were taking place in New York City. The first underground trains, the IRT subway, started running on the East Side of Manhattan in 1904, followed by the Seventh Avenue IRT in 1917.

And during these early years of the New York City subway system, travel between New Jersey and New York underwent a major transformation, as trains started crossing the Hudson River through cast-iron tubes built along the riverbed.

Construction began in these tunnels, known as the Hudson Tubes, in 1890, but due to lack of funds, the project was abandoned for ten years. It resumed under the direction of William Gibbs McAdoo, who saw the project through to completion. In fact, the Hudson Tubes were sometimes called the McAdoo Tunnels. McAdoo became the president of the Hudson and Manhattan Railroad, which initiated service between lower Manhattan and New Jersey in 1909. (The Hudson Tubes were designated as a National Historic Civil Engineering Landmark by the American Society of Civil Engineers in 1978.)

By the mid-twentieth century, the Hudson and Manhattan Railroad had fallen on hard times. In 1962, it filed for bankruptcy, and the Port Authority of New York and New Jersey assumed operation of the company, spending $62 million to restore the system—the first of many restorations. The name was changed to the PATH, the Port Authority Trans Hudson, and it continues to be one of the busiest commuter lines in operation.

And here we are at one of the most attractive of the PATH train stations. Located at 135 Christopher Street, between Greenwich and Hudson Streets, the station was restored by the Port Authority in 1985. It was cited in the *AIA Guide to New York City* as "a wondrous restoration of this sadly neglected amenity." Often compared to one of the original

Christopher Street, the Ninth Avenue El and the Story of William "Bill the Butcher" Poole

London Underground entrances, the old-fashioned marquee and colorful decoration make this PATH entrance well worth a stop on our visit to Christopher Street.

The station entrance still has its original marquee that reads "Hudson Tunnels," a reminder that this was once the Hudson and Manhattan Railroad Company. Along the interior walls of the station is a series of murals painted by Biff Elroy in 1986. Entitled *Ascent-Descent*, the thirteen panels decorating the walls as you go down three levels to the PATH platforms depict commuters going up and down the stairs. They were originally a temporary installation commissioned by the Public Art Fund but were subsequently purchased by the Port Authority and restored in 1999.

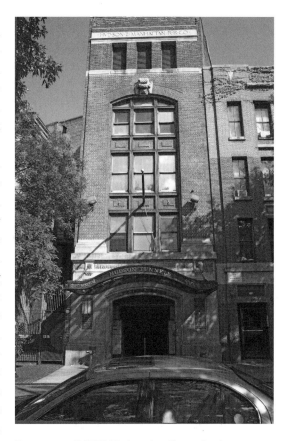

Entrance to PATH Christopher Street Station, original marquee.

Let's get back to the story of the Ninth Avenue El.

The expansion and success of the various underground train lines pretty much sounded the death knell for the elevated lines. The Ninth Avenue El trains stopped running in 1940, and fifteen years later, in 1955, the last elevated tracks in Manhattan, running along Third Avenue, were demolished. (This is not, however, the case in Brooklyn, Queens or the Bronx, where both elevated and underground trains operate around the clock. About 40 percent of the New York City train service is still along elevated tracks.)

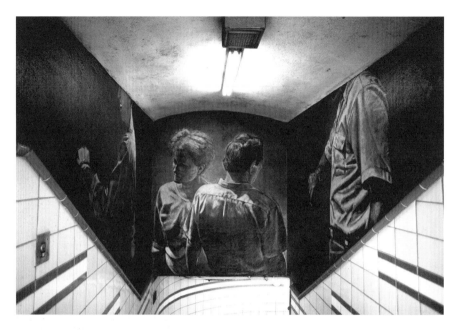

Ascent Descent mural, Christopher Street PATH Station interior.

The absence of the Ninth Avenue El, however, gives us a good view of St. Veronica's Roman Catholic Church, located at 153 Christopher Street, between Greenwich and Washington Streets. Built in 1889, the church was founded by Father John FitzHarris to serve the large Catholic population, many of whom arrived from Ireland during the immigration wave of the 1880s. Father FitzHarris also established St. Veronica's Catholic Grammar School one block over on West Tenth Street. Gene Tunney, "the Fighting Marine," whom we'll meet in the next chapter, went to St. Veronica's School in the early twentieth century.

St. Veronica's Catholic School is now the Village Community School, and St. Veronica's Church is a mission house affiliated with St. Bernard's Catholic Church, located on West Fourteenth Street. Although it is now called the Mission of Our Lady of Guadalupe, the church is still known locally as St. Veronica's. St. Veronica's Rectory, located nearby at 657 Washington Street, is now the House of Love, an AIDS hospice, staffed by Missionaries of Charities, founded by Mother Teresa.

Christopher Street, the Ninth Avenue El and the Story of William "Bill the Butcher" Poole

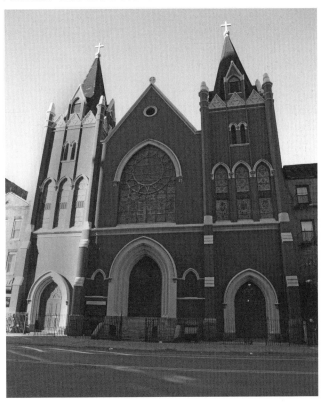

St. Veronica's Church, Christopher Street, built in 1889.

Let's go back in time to the early nineteenth century when Christopher Street was home to William "Bill the Butcher" Poole, whose story was dramatized in Martin Scorcese's 2002 movie, *Gangs of New York*. Convincingly portrayed by Daniel Day Lewis, the fictional character of Bill the "Butcher" Cutting was actually a composite of two historical figures, Isaiah Rynders (1804–1885) and William Poole (1821–1855).

And an interesting combination that proved to be. Isaiah Rynders was a successful businessman who also happened to be a leader of the New York underworld. He provided the muscle behind Tammany Hall (the New York political machine), organizing street gangs to intimidate voters and guarantee election results for chosen candidates (including, rumor has it, more than one U.S. president).

The leader of a gang of thugs who ruled the Five Points neighborhood of Manhattan, Rynders's brutality inspired fear in his friends as well as his enemies. His name has been associated with the Astor Place Riot of May

1849, a violent fight between the "nativists" (a working-class, American-born, anti-immigrant population) and the mostly Irish immigrants, resulting in 25 deaths, more than 120 injured and considerable damage to the Astor Place Opera Theatre on Broadway, which closed a few years later. Rynders probably did not get his hands dirty, but his Five Points Gang led a crowd of 20,000 in the rioting. Many of the dead were innocent bystanders who were killed when the National Guard, called in to control the riot, opened fire on the crowd.

Despite his bloody history, Rynders had a street named for him. Centre Street in lower Manhattan was originally named Rynders Street and was famous for its brothels and dens of vice. (Ironically, 240 Centre Street was the home of New York City Police Headquarters between 1909 and 1973. The building was subsequently converted into luxury condominiums.)

But it is William Poole who captures our attention. A longtime resident of Christopher Street, Poole came to New York from New Jersey at the age of eleven, at which time his father, a butcher, opened a shop in the Washington Market. After serving an apprenticeship, Bill the Butcher opened his own butcher shop in the same market. A handsome, personable fellow, successful at his trade, Bill also developed a reputation as a street brawler and was known for his skill at "handling knives."

When he wasn't working, he was involved in local gang activities and was a member of the Red Rover Volunteer Fire Department, Fire Engine Company 34, located at Hudson and Christopher Streets. The Red Rovers, when not fighting fires, had an ongoing feud with another local fire company, the North River Engine Company 27, often resulting in fisticuffs (and worse).

William Poole was also politically active. He was a member of the anti-immigrant Native American Party, also known as the Know-Nothing Party. Membership in the Know-Nothings (so-called because their policy, when queried about their activities, was to reply, "I know nothing"), was limited to white Protestant men. Anti-Catholic, anti-Irish and anti-German, the Know-Nothings feared the power of the pope over nonnative Americans. The Native American Party became a national political party in 1845, later changing its name to the American Party. Bill the Butcher joined the Native Americans in 1851, and his Washington Street gang served as "shoulder hitters," enforcing the will of the party boss by means of

threats and violence. They played an important part in persuading voters to make "the right choice."

Bill the Butcher died unpleasantly, not long after a brutal fight with prizefighter John Morrissey. Morrissey, an Irish immigrant and an enforcer for Tammany Hall, represented the very people that Poole's Native American Party loathed, but their dispute was purportedly about a boxing match. To settle their differences, the two men engaged in a bare-fisted battle "at the foot of Amos Street, North River" (currently Charles Street, Hudson River), according to a *New York Daily Times* report on July 28, 1854. Poole's bloody victory over Morrissey was followed by threats of vengeance on the part of Morrissey's cohorts. Bill the Butcher was shot by Morrissey's friend, Lew Baker (who was never convicted), and died of his wounds in his home on Christopher Street in February 1855. John Morrissey, a protégé of Isaiah Rynders, eventually replaced Rynders as head of the Sixth Ward, the Five Points area of lower Manhattan, located between Broadway and the Bowery, which was the setting of *Gangs of New York*.

Bill the Butcher's death, however, was romanticized by the press. Poole's friends and followers gathered at his bedside, and the streets around his house were crowded with his admirers. Poole's last words, "Good-bye boys, I die a true American," spread through the crowd and were quoted in newspapers, plays, even vaudeville acts (and were paraphrased in Martin Scorcese's movie). He was glorified as the true American, murdered by one of the immigrants he despised.

An interesting footnote to this tale is that Bill the "Butcher" Cutting, the composite character in the movie, was depicted as dying during the Draft Riots of 1863, eight years after William Poole's ignominious death and twenty-two years before Rynders, who died in his bed at the age of eighty-one.

At this end of Christopher Street, about forty years after Bill the Butcher met his match, the United States government built a warehouse that occupied an entire city block, from Christopher Street to Barrow Street and Washington Street to Greenwich Street. Originally called the U.S. Appraisers' Store and later the U.S. Federal Archives Building, this landmarked building was erected between 1892 and 1899 as a Treasury Department warehouse for imported goods awaiting customs appraisal.

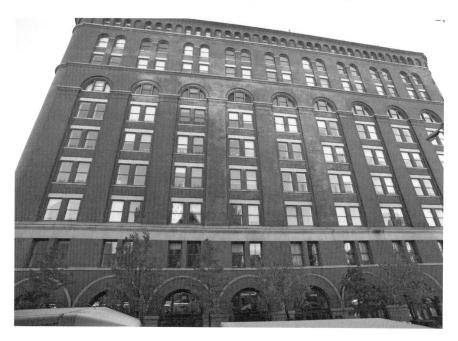

Archives Apartments, 666 Greenwich Street.

Converted for residential use in 1988, it is now called the Archives Apartments and contains 479 apartments.

Right across Christopher Street is St. Veronica's Church, which played a role in the life of the Fighting Marine (Chapter 3).

CHRISTOPHER STREET CONTINUED

*The Fighting Marine, the Stonewall Inn, Lucille Lortel
and the Theater de Lys*

W e are now standing at the foot of Christopher Street, looking
across the Hudson at New Jersey. Try to imagine the once
glorious—and now vanished—Hoboken Ferry Pier that stood here for
seventy-five years.

The building was originally the New Jersey State Pavilion from the 1876
Philadelphia Centennial Exhibition, officially known as the International
Exhibition of Arts, Manufactures and Products of the Soil and Mine.
This was the first World's Fair in the United States, commemorating the
100th anniversary of the signing of the Declaration of Independence
in Philadelphia. It was at the Philadelphia Centennial Exhibition, by
the way, that the right arm and torch of the *Statue of Liberty* were first
displayed! Visitors could climb a ladder to the balcony for a fee of fifty
cents. And the money collected was used to pay for the construction of
the rest of the statue.

The New Jersey Pavilion building was purchased by Edwin Stevens
when the exhibition was finally taken down in 1881. It was transported
to Manhattan and reassembled here at the foot of Christopher Street,
where it was transformed into the Hoboken Ferry Pier.

But who was Edwin Stevens, one might ask, and why did he make
this grand gesture? Stevens's father, Commodore Edwin Augustus
Stevens (1795–1868) and his older brother, Robert, "owned the entire
waterfront of New Jersey and established the Hoboken Ferry," according

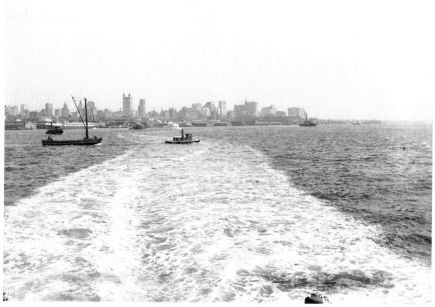

New York Harbor from the Hoboken ferry. *Courtesy of Library of Congress, Prints & Photographs Division, Detroit Publishing Company Collection.*

to an obituary in the *New York Times* on April 2, 1899, for Commodore Stevens's widow, Mrs. Martha B. Stevens. The Stevens brothers founded the Camden and Amboy Railroad and Transportation Company, the first commercially successful railroad in the United States, a forerunner of the Pennsylvania Railroad. A bequest by Commodore Stevens laid the foundation for the establishment of Stevens Institute of Technology in Hoboken in 1870. Oh, and let's not forget their father, Colonel John Stevens (1749–1838), who was the founder of the town of Hoboken.

Commodore Stevens's son, Edwin Augustus Stevens Jr. (1858–1918), was the president of the Hoboken Ferry Company and inventor of the propeller-driven, double-ended ferry, which revolutionized ferry design in the early twentieth century; it is still in use today. He was in his early twenties, however, when he purchased the New Jersey Pavilion and moved it to the Manhattan side of the Hudson. Sadly, it was demolished in 1953.

Let's head back along Christopher Street and make the acquaintance of Gene Tunney, the "Fighting Marine." We'll stop in front of St. Veronica's Church, which Tunney's family attended.

James Joseph "Gene" Tunney was born in 1897 to Irish immigrant parents from County Mayo who settled in the West Village in the 1880s. Tunney's father was a longshoreman, working on the Hudson

West and Christopher Streets, as it looks today.

River docks in the West Village. A great fan of boxing, Tunney Sr. enjoyed going to "smokers," amateur boxing matches, generally held in smoke-filled halls of the Knights of Columbus or other fraternal organizations. Smokers were popular in New York from the 1880s until after World War I. Although professional boxing was illegal in New York, these informal matches attracted an enthusiastic audience, especially among a rough crowd of Irish and Italian immigrants, who would bet against and fight with one another. Smokers were held at irregular intervals, usually on Friday and Saturday nights. Although not legal, the police did not interfere; in fact, off-duty officers were often hired to keep the peace.

111 Bank Street, childhood home of Gene Tunney.

His love of the sport, coupled with concern for his son, Gene—a tall, skinny lad, often set upon by local bullies—inspired the elder Tunney to buy Gene a pair of boxing gloves for his tenth birthday. It was the hope of Tunney's father that Gene would learn to defend himself against the local hoodlums.

Young Gene was beaten up by the neighborhood toughs for other reasons as well. A good student at St. Veronica's Grammar School, he was often seen reading or carrying around library books, which did nothing for his reputation on the streets of Greenwich Village. Indeed, even in later years, when Tunney was the heavyweight champion of the world, his bookishness and what was perceived as his intellectual snobbishness detracted from his popular appeal.

Although his parents wanted him to enter the priesthood, Tunney's gift for boxing was quickly apparent. He learned how to spar at the gym at PS 41 Evening Recreational Center, located at Charles Street and Greenwich Avenue, and joined the marines during World War I.

The story goes that when a drill sergeant spoke deprecatingly of Tunney's parents, Tunney protested, and in time-honored fashion, they decided to settle their differences behind the barracks. Not surprisingly, Tunney, already an accomplished boxer, knocked his opponent out in twenty seconds. When the sergeant recovered consciousness, he invited Tunney to box for the company. Tunney became light heavyweight champion of the U.S. Expeditionary Forces, and when the war was over, he embarked on his professional boxing career. Fortunately for him, professional boxing had attained legal status by then.

It was quite a career. Spanning only a few years, Tunney won sixty-seven out of sixty-eight professional fights, losing only once (to Harry the "Human Windmill" Greb, whom Tunney later defeated in four rematches) and holding the world heavyweight title between 1926 and 1928.

Tunney's fame spread beyond boxing circles when he defended his title against Jack Dempsey and defeated him in 1926 and again in 1927 in a match known as the "Long Count."

The story of the Long Count is familiar to boxing aficionados. During the fight, a controversy arose over the then new regulation requiring a boxer to return to his corner after knocking down his opponent. Dempsey, who had knocked Tunney down, at first remained hovering over his fallen opponent, and the extra time it took the referee to move

Dempsey to a neutral corner gave Tunney the extra seconds he needed to recover, ultimately win the fight and retain the title. Tunney's victory, however, remains in dispute and is still discussed nearly a century later.

Dempsey, by the way, is credited with the line "Honey, I forgot to duck," reportedly explaining to his wife his defeat by Tunney in their 1926 bout.

Upon his retirement from boxing in 1928, Tunney married Mary Lauder (1907–2008), one of the richest women in the world and a grand-niece of Andrew Carnegie.

Although his formal education ended in high school, Gene Tunney remained a reader and a scholar. He wrote two autobiographies, *A Man Must Fight*, published in 1932, and *Arms for Living*, in 1941.

Tunney numbered among his friends and correspondents some of the most illustrious figures in twentieth-century literature. He and George Bernard Shaw, who was forty years his senior, were friends for many years and shared their passions for literature and sports. (Shaw was a boxing enthusiast.) Tunney was also friends with playwright Thornton Wilder, Ernest Hemingway and Hugh Walpole.

But his greatest academic achievement was when he was invited to lecture at Yale University. How did this come about? Gene Tunney met Professor William Phelps, who taught courses on Shakespeare at Yale, on the golf course in 1927. Having read about Tunney's interest in Shakespeare, Phelps invited Tunney to speak to his class. Tunney accepted but asked Phelps to keep the visit quiet; this was, after all, only a few months after Tunney's defeat of Jack Dempsey. Word got out, however, and Tunney arrived at Harkness Hall to find five hundred students and members of the press awaiting him. Although he expected to talk to the class about boxing, Phelps asked him to speak about Shakespeare. Despite being taken a bit off guard, Tunney managed quite well, quoting from Shakespeare, Thomas Carlyle and Herbert Spencer and focusing his talk on *Troilus and Cressida*. His one reference to boxing was a comparison between Ajax and boxer Jack Sharkey, "Now Ajax was a big, powerful man without much brains; just like Jack Sharkey."

Tunney's brief film career consisted of the starring role in *The Fighting Marine*, made in 1926. No prints seem to have survived. The movie may be forgotten, but the nickname remains.

He and Jack Dempsey remained friends for the rest of their lives. In fact, Dempsey campaigned for Tunney's son, John V. Tunney, who was

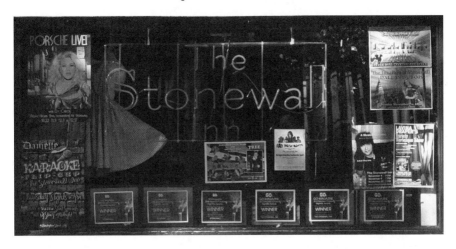

The Stonewall Inn.

elected to the U.S. House of Representatives and served as senator from California from 1965 to 1977. Gene Tunney died in 1978, and Dempsey five years later.

Moving away from the former dock area at the end of Christopher Street, where our friend the Fighting Marine spent his early years, let's head for 53 Christopher Street and pay a visit to the Stonewall Inn, birthplace of the modern gay rights movement.

The Stonewall Inn began its life as two adjacent stables built in the 1840s. The buildings housed restaurants between the 1930s and 1966, including one called the Stonewall Inn Restaurant during the '50s. After being closed for a year, the Stonewall Inn was reopened as a gay bar and dance hall. It attracted large, noisy crowds and was frequently raided by the police, ostensibly looking for payoffs. Like most gay clubs at the time, the Stonewall Inn did not have a liquor license. And also like most gay bars, it was owned by members of organized crime families who used bribery to keep the police at bay and raids down to a minimum.

Increased tensions between the Stonewall Inn regulars and the New York Police Department culminated in the explosive night of June 28, 1969, now known as the night of the Stonewall Riots. A routine raid by two uniformed police officers and four plainclothes policemen turned into a fight between the police and the patrons. Objects were hurled,

punches were thrown and the fight escalated, as crowds of angry men faced off against the New York Tactical Police Force, which was called in to control the crowd. The riots raged into the next day and started again the following night along Christopher Street. The fighting continued sporadically during the next few days.

One significant result of the Stonewall Riots was certainly the media attention that was focused on gay rights—or the lack thereof. If a single date can be fixed, June 28, 1969, has been designated as day one of the gay liberation movement. The Gay Liberation Front, the Gay Activist Alliance and various other organizations and publications were soon in place. The first gay pride march was held on June 28, 1970, commemorating the first anniversary of the riots, and gay pride has become an annual celebration each June in cities around the world. In fact, a number of German cities call it "Christopher Street Day." But the place to be, perhaps, is Amsterdam, where the canals of the city are afloat with elaborately decorated boats filled with dancing celebrants, and the entire city comes out to cheer them on.

Concerning the historical significance of June 1969, David Carter, author of *Stonewall: The Riots That Sparked the Gay Revolution* (New York: St. Martin's Press, 2004), was quoted in the *New York Times* on September 9, 2010: "The Stonewall uprising is the signal event in American gay and lesbian civil rights history because it transformed a small movement that existed prior to that night into a mass movement. It is to the gay movement what the fall of the Bastille is to the unleashing of the French Revolution."

The fortunes of the Stonewall Inn have waxed and waned in the years since 1969. The bar was closed after the riots. The building housed numerous other businesses between 1969 and the early 1990s, when it reopened as a new gay bar called Stonewall. A few other bars have come and gone in the same location since then, but today the Stonewall Inn is back in business with its original name.

Christopher Street, once the capital of gay pride, has toned down a little, with much of New York's gay social scene having moved uptown to Chelsea. But the Stonewall Inn and the area immediately around it is now listed in the National Register of Historic Places and has been designated a National Historic Landmark since 2000.

Included in this National Historic Landmark area is Christopher Park, which is located almost across the street from the Stonewall Inn (though

it is technically not a part of the Original West Village). The park was created on a small triangle of land whose houses were destroyed by a fire in 1835. As a result of a petition filed by residents of the neighborhood, the city turned this small area, bounded by Christopher, Grove and West Fourth Streets, into a park in 1837.

Backtracking a bit, historically, between 1789 and 1829, Christopher Street was subdivided into building lots and blocks, laid out irregularly along its length. Sometimes oddly shaped, these blocks do not follow a grid plan. In the early years of the nineteenth century, the population of Greenwich Village expanded dramatically, and the area around Christopher Street became dangerously overcrowded. The fire that led to the creation of Christopher Park was one of many that destroyed much of the neighborhood in the 1830s.

Today, Christopher Park is a part of Sheridan Square, also on the wrong side of Christopher Street (i.e., outside our Original West Village boundaries). But we should have a look at the sculpture *Gay Liberation*

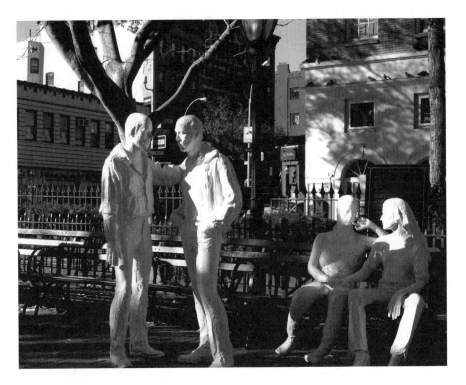

Gay Liberation, sculpture by George Segal.

by George Segal, installed in 1992, which commemorates Christopher Street's contribution to gay pride and the gay liberation movement.

Half a block farther along, on the north side of Christopher Street, we find St. John's Evangelical Lutheran Church. A New York City Landmarks Preservation building, St. John's was built in 1821 as the Eighth Presbyterian Church and is one of the oldest churches in Greenwich Village. In 1842, the name was changed to St. Matthew's Episcopal Church, which was sold to the German Lutherans in 1858 for $13,000, at which time it became St. John's. The building is Federal in design with a domed cupola.

It was here that *Tony & Tina's Wedding* played between 1988 and 1999. *Tony & Tina's Wedding*, which was originally conceived as an improvisation by two Hofstra University drama students (Mike Nasser and Nancy Cassaro, who originated the title roles), is interactive or environmental theater. It is an improvisational comedy in which audience members participate in an Italian wedding and reception. During the first eleven years of its run, the wedding ceremony was performed here in St. John's Church; the show later moved to a church on Washington Square. *Tony & Tina's Wedding* has since been staged in over one hundred locations around the world.

Although Tony and Tina have moved on, St. John's Evangelical Lutheran Church still serves the Greenwich Village Community in more ways than one. In addition to Sunday Mass and communion, it offers a weekly Jazz Mass, a coffee house with music performances, yoga classes and exhibitions.

While we're on the subject of theater, let's walk one block west and pause in front of one of the oldest Off-Broadway theaters, the Lucille Lortel Theater, located at 121 Christopher Street, and pay our respects to its founder. Originally known as the Theater de Lys, the building was purchased as an anniversary present from industrialist Louis Schweitzer (1899–1971) to his wife, Lucille Lortel. Actress and producer, Lortel (1900–1999) opened her theater in 1953 and was responsible for the production of numerous plays with social and political content. A fighter for social justice, sexual and racial equality, Lortel was named the "Queen of Off-Broadway" in 1962 by the *Washington Post*, and the theater was renamed in her honor on the occasion of her eighty-first birthday.

Bertolt Brecht and Kurt Weill's *The Three Penny Opera* had its New York premiere at the Theater de Lys in 1954, starring Weill's wife, Lotte Lenya. Weill and Lenya had arrived in New York in 1935, fleeing from Nazi Germany. Married in 1926, they divorced in 1933 and remarried in 1937. Other members of the original cast included Edward Asner, Beatrice Arthur, Jerry Orbach and Jerry Stiller. *The Three Penny Opera* played 2,707 performances and netted Lotte Lenya a Tony Award.

Greenwich Village is home to a number of other Off- and Off-Off-Broadway theaters, but the Lucille Lortel Theater is the most significant one in the Original West Village.

Chapter 4

WEEHAWKEN STREET (THE SHORTEST STREET IN MANHATTAN), NEWGATE PRISON AND THE EMPIRE BREWERY

Our stroll has brought us back to the Hudson River, and this time we're going to walk one block back along Christopher Street and turn left.

Here we are on Weehawken Street, the shortest street in Manhattan and the center of the Weehawken Street Historic District, so designated in May 2006 by the New York City Landmarks Preservation Commission. Weehawken Street, running north–south between Christopher and West Tenth Streets, fits neatly in between Washington Street on the east and West Street on the west.

Only one block long, there are fourteen buildings along Weehawken Street, including one of the oldest surviving houses in the Village, 6 Weehawken Street, also referred to in city records as 392 West Street, which is its street address at the rear. George F. Munson, a boat builder, purchased the building from the city for $1,550 and occupied it between 1850 and 1855. Munson ran a restaurant on the ground floor, known as the Old Oyster House or the Munson House, although he never lived there. (His home was nearby, on Christopher Street.)

The oyster trade was very active in nineteenth-century New York, and oyster bars were popular gathering places in Manhattan's waterfront neighborhoods. The oyster trade was dominated by African Americans, many of whom lived in the Weehawken neighborhood during that period of time.

Weehawken Street (the Shortest Street in Manhattan), Newgate Prison and the Empire Brewery

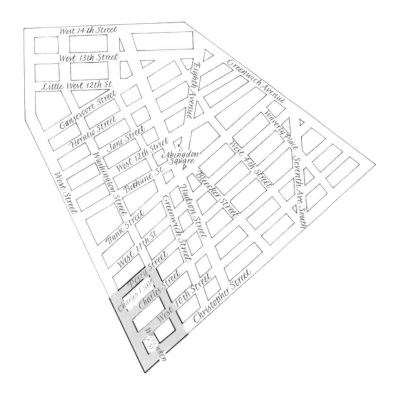

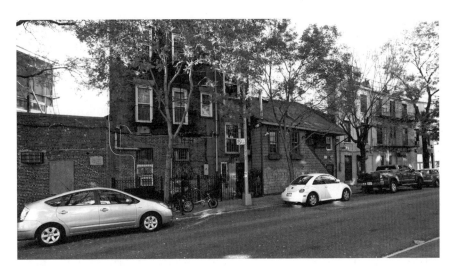

Weehawken Street.

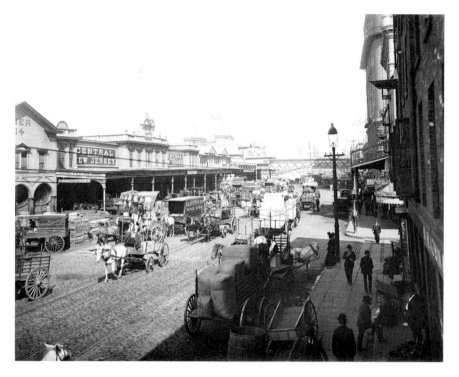

West Street, circa 1900. *Courtesy of Library of Congress, Prints & Photographs Division, Detroit Publishing Company Collection.*

The house at 6 Weehawken Street is odd looking, probably unique in New York City. A wood-framed building, it has an exterior staircase and a peaked roof. It was built in 1834 and altered in 1848, just one year before fire laws prohibiting wood-frame construction were passed in New York City. It may well have been the last wood-framed building erected in the city.

The buildings along Weehawken Street have gone through various renovations and restorations, but this one has kept its original character. An engraving of 6 Weehawken Street appeared in *Harper's New Monthly Magazine* in 1893. It looks about the same today.

Most of the buildings along Weehawken Street were built and/ or rebuilt between 1830 and 1938 and were used for commercial purposes, including maritime enterprises such as marine repair shops, coppersmiths and wheelwrights, as well as stables, alehouses and oyster and clam bars. Number 2 was listed in 1850 as a "lime dealer" and the

Weehawken Street (the Shortest Street in Manhattan), Newgate Prison and the Empire Brewery

9–11 Weehawken Street, contemporary view.

building next door as a porterhouse, one of the first of many saloons in the Original West Village.

Weehawken Street was "regulated and paved," according to a petition approved in 1830 by the New York Common Council, but the road was already indicated on early property maps in the late eighteenth century, when the city purchased the land as the building site of Newgate Prison.

Newgate Prison, officially known as the State Prison at Greenwich, was New York State's first penitentiary and the first of three along the Hudson River. It opened in 1797 on a four-acre site situated between Christopher and Perry Streets and Washington Street and the Hudson River shoreline; in fact, its western end was built right into the river. Built at a cost of $208,000, the prison had high stone walls, including a twenty-two-foot one on the river side, and held seven hundred male and female prisoners.

The architect of the building was Joseph Francois Mangin, who, in partnership with John McComb Jr., designed New York's City Hall, which was built between 1803 and 1812.

A brief aside: Mangin and McComb were awarded the contract to design a new City Hall as a result of a competition. They beat twenty-six

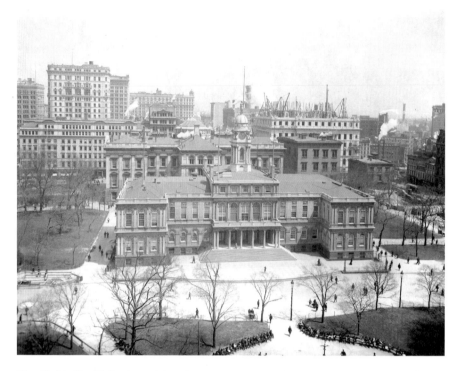

New York's City Hall, pictured here in 1903, was designed by Joseph Francois Mangin and John McComb Jr. In 2003, Mayor Michael Bloomberg paid homage to the building's architects. *Courtesy of the Library of Congress, Prints & Photographs Division, Detroit Publishing Company Collection.*

other architects and won a prize of $350 for their design. This was the third City Hall; the first of which, in the seventeenth century, was called the "Dutch City Hall" and was located in a tavern on Pearl Street. Mangin and McComb's City Hall was built at the northern limits of New York City on park land, then called the Commons and now City Hall Park.

The collaboration between Mangin and McComb is an interesting chapter in architectural history. Joseph Francois Mangin was a free black Frenchman who had been trained in Paris at the Ecole des Beaux-Arts. He combined his French architectural sensibility with that of American-born John McComb Jr. *The AIA Guide to New York City* calls City Hall "a mini-palace, crossing French Renaissance detail with Federal form, perhaps inevitable where the competition-winning scheme was the product of a Frenchman and the first native-born New York City architect." The design of the building features French Renaissance decorative details on the façade; this has been attributed to Mangin, who worked on the Place

Weehawken Street (the Shortest Street in Manhattan), Newgate Prison and the Empire Brewery

de la Concorde in Paris before coming to the United States. The overall shape of the building, which is Federal in style, shows McComb's hand.

Mangin is also credited with the design of the first St. Patrick's Cathedral, which opened on Mott Street in 1915.

In 2003, New York mayor Michael Bloomberg commemorated the 200th anniversary of City Hall, paying special homage to its architects.

Newgate Prison was built outside the city. Many prisoners arrived at Newgate by boat after being sentenced in the law courts downtown and were transported from the old Bridewell Prison in what is now City Hall Park. The term "being sent up the river" dates from this time. (Didn't Sam Spade say to Brigid O'Shaughnessy in *The Maltese Falcon*, "Sweetheart, I'm sending you up the river," or words to that effect?) Newgate Prison had its own pier for this purpose, built at the foot of Christopher Street.

When Newgate Prison opened, it was considered a model prison, where physical punishment was banned. In theory, at least, inmates would be reformed and rehabilitated. Among its facilities were bathing rooms, a chapel and workshops where prisoners could be taught a trade.

The former site of Newgate Prison.

Overcrowding and a volatile mixture of adults, juveniles and "the insane" led to several prison uprisings and attempts to burn the buildings down. Residents of the area were soon agitating for removal of the prison from their backyards. It was claimed, in fact, that the progressive policies of Newgate, which permitted prisoners to congregate in the workshops, enabled them to conspire against prison authorities, leading to revolts and uprisings.

By 1829, Newgate Prison was gone, and the prisoners were relocated to Sing Sing, a larger, newer facility that had opened its doors in 1828. Once again, the prison inmates were sent up the river.

In its heyday, however, Newgate Prison was one of New York's earliest tourist attractions, with its massive walls and dramatic location. In fact, ferry service between Hoboken and the prison pier was established in 1799, and the Greenwich Hotel, which opened in 1809, became a popular summer resort!

A major selling point of Newgate Prison, incidentally, had been the clean, fresh air of the riverfront location. The theory was that the healthy environment would go far toward the rehabilitation of prison inmates. Unfortunately this was not the case, possibly because they didn't have access to much of the fresh air. With the removal of the prison, however, the building was converted to a sanatorium spa by Jacob Lorillard, who purchased the prison buildings in 1831.

Lorillard (1774–1838) was heir to the American Tobacco Company fortune. The company was established by his father, Pierre Abraham Lorillard (1742–1776) in 1760. The name was changed to Lorillard Tobacco in 1911 and still exists as Lorillard, Inc., located in Greensboro, North Carolina; they make Newport cigarettes.

But, back to Jacob. Jacob Lorillard was successful in his own right, independently of his family. A prosperous leather merchant, Lorillard was also the president of the Mechanic's Bank, which he bailed out financially twice. A philanthropist who was known for his public works, he also invested heavily in New York City real estate, which included the purchase of Newgate Prison.

Meanwhile, further development was taking place in the riverfront area. After the disappearance of the prison, a new pier opened at the end of Christopher Street, and ferry service brought lumber to the city and produce to the Manhattan markets. In 1834, the city Common

Weehawken Street (the Shortest Street in Manhattan), Newgate Prison and the Empire Brewery

Council appropriated $3,475 for construction of a new city market, and the New Greenwich Market—there was another Greenwich Market a few blocks away—also known as the Weehawken Market, was built. Consisting of a long open wooden shed, it extended along West Street between Christopher and Amos Streets (today's West Tenth Street).

But it was not successful. The New Greenwich Market lasted only ten years and was removed in 1844, making way for George Munson and his various properties.

There is a bit of confusion, by the way, about the New Greenwich Market and the history of 6 Weehawken Street. According to city records, the Greenwich Market House and the grounds upon which it was built was sold at public auction in 1848 and divided into seven building lots. Two of these lots were purchased by Munson, who added to the existing structures before opening his businesses in 1850. Interestingly enough, some forty years later, when Greenwich Village began to assume its character as a bohemian enclave, the row houses along Weehawken Street attained considerable popularity among local artists and photographers for their picturesque quality. It was at this time that a myth, or perhaps a rumor, was promulgated that these buildings were pre-Revolutionary (i.e., that they were built before 1776). It is more likely, however, that the buildings along Weehawken Street, happily preserved as the Weehawken Historic District, date only from the 1830s, not the 1770s. (To European visitors, that's not old; but to New Yorkers, it's definitely historic!)

One last stop on our "disappearing prison tour" is the Empire Brewing Company, also known as Beadleston & Woerz, which was one of the more impressive uses of the prison buildings. Ebenezer Beadleston (1803–1889) was a merchant who sold the ales of A. Nash & Company, from Troy, New York, starting in 1837. Beadleston joined Nash to establish their own brewery: Nash, Beadleston and Company in 1845, along West Tenth and Washington Streets. The brewery was an immediate success, and by the time Beadleston's sons, William Henry Beadleston (1840–1898) and Alfred Nash Beadleston (1835–1916), and Ernest G.W. Woerz took over the company, it was one of the largest brewers in the United States. (What happened to Nash? One can only guess.)

Shepherd House Apartments, 277 West Tenth Street, built on the site of Newgate Prison.

Extolling its health benefits, Beadleston & Woerz Imperial Beer was promoted as "healthful, invigorating and refreshing and should be considered for its digestive properties," a good example of nineteenth-century advertising hyperbole.

By the 1880s, the Empire Brewing Company had outgrown its premises, and the old prison building was replaced with new construction. Beadleston & Woerz survived as a brewery until 1937, at which time Prohibition was taking its toll on the liquor business. The brewery

buildings were torn down, and warehouses were built in 1939, which were recently converted to luxury residences.

Beadleston & Woerz, however, survived the Depression intact, if not as a brewery. Having purchased numerous buildings and building lots throughout the West Village, they effortlessly moved into the real estate business and continued to prosper.

And here's a little society note: According to an article in the *New York Times* on April 6, 1893, Miss Caroline Woerz, daughter of Mr. and Mrs. Ernest G.W. Woerz, married James Steele. "The bride received many handsome presents, among them a furnished house and a well-stocked stable from Mr. Woerz."

Chapter 5

WEST TENTH AND CHARLES STREETS

Pig Alley, The Runaway Bunny *and Diane Arbus*

W e're continuing along on West Street, pausing when we come to West Tenth. The street was originally called Amos Street, named for Richard Amos, one of the heirs to Sir Peter Warren's vast estate. (Another relative, Charles Christopher Amos, gave his name to both Christopher and Charles Streets but not to Amos Street. It's all a little confusing.)

At this location, West and West Tenth Streets, there is quite a mix of the old and the new: restored stable buildings, a tenement building dating from 1873 with the original façade intact and, one block farther along at Charles Street, a carriage house from the 1880s that was used by the Jefferson Market Courthouse. The horses lived on the second floor, or so we've been told.

Two extremely different historical events took place on the corner of West Tenth and West Streets. This was, for a number of years, the location of the Ramrod, a notorious gay/leather bar that attracted a late-night crowd to this dark corner of the city. In 1980, a former Transit Police officer opened fire outside the Ramrod with an Uzi, killing two men and injuring six others. He was found not guilty on the grounds of insanity but spent most of the next twenty years in a psychiatric prison, from which he was later released.

The Ramrod eventually closed its doors, but it reopened at 185 Christopher Street in 2009. The corner of West and West Tenth Streets, where the original Ramrod stood, once considered a sinister part of town, now features several popular restaurants.

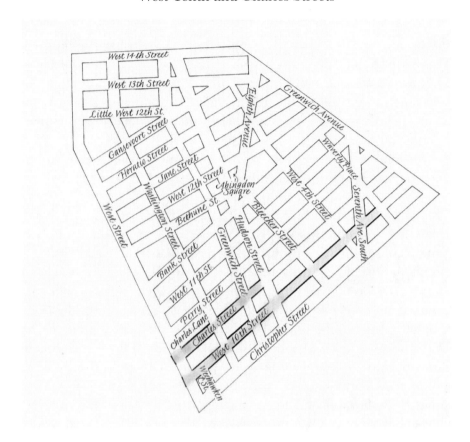

While we are on the subject of gay bars, another important West Village watering hole, a few blocks away at the eastern end of the Original West Village, is Julius' Bar, at 159 West Tenth Street. The building dates from 1826. Originally a grocery store, it has been operating as a bar since 1864, which makes it one of the oldest bars in the city. Julius' was a speak-easy during Prohibition. Its location near several important Village jazz clubs made it a hangout for musicians during the 1930s and '40s, including Fats Waller.

Julius' is also the oldest gay bar in the Village, where one might have seen Truman Capote and Tennessee Williams, as well as Rudolf Nureyev. In 1966, one of the pivotal gay rights events took place here, a "sip-in," protesting laws prohibiting bars and restaurants from serving homosexuals. Staged by the Mattachine Society (a gay rights group that flourished during the 1950s and '60s), several members of the group, in the presence of newspaper reporters, ordered drinks at the bar, first

stating publically that they were homosexual, thus challenging the New York State Liquor Authority's ban on serving "the disorderly" (which was conveniently equated with homosexuality). The refusal on the part of the bartender to serve them, and the subsequent news coverage, precipitated an investigation by the New York City Human Rights Commission and repeal of the law.

This took place three years before the Stonewall Riots and was an important step in the gay liberation movement.

Let's walk back to the waterfront and go back nearly two hundred years. It was here, from the Hudson River Pier at West Tenth Street that Robert Fulton launched the first commercially successful steamboat in 1807.

Fulton (1765–1815) was quite a smart fellow. He started tinkering with inventions in his preteen years, and before he was out of his twenties, he designed a working submarine, the *Nautilus*, first submerged in France in 1800. Fulton, however, did not build the very first submarine. A Dutchman, Cornelius Drebbel (1572–1633) invented the first navigable submarine in 1620, for the English Royal Navy. Drebbel is also credited, along with a few other people, with the invention of the microscope and also with the first air conditioning.

There were a number of steam-driven vessels being tested before Fulton came along; as early as the first quarter of the eighteenth century, steamboats were being developed in the United States. Robert Fulton, however, in partnership with Robert Livingston, built a steamboat in France, which made its maiden voyage along the Seine River in 1803. Four years later, Fulton and Livingston built the *North River Steamboat*, which left the Hudson Pier at West Tenth Street on August 17, 1807, carrying passengers up the river to Albany. The North River Steamboat was later, perhaps erroneously, called the *Clermont*, which is the name by which most of us know it today.

An interesting note about Fulton is that he was also a successful fine artist, the sale of whose paintings helped support his hobby as an inventor. This is quite the reverse of the story of many artists today, who support their painting hobby with better-paying jobs!

We're now going to head a little farther north, in fact half a block farther, to a little street slipped in between West and Washington Streets. This is

Charles Lane, looking west toward West Street.

Charles Lane, and like Weehawken Street, it's one block long. (It would be nice to tell you that this is the second shortest street in Manhattan, but it isn't. There are several other one-block long streets in Manhattan that are longer than Weehawken Street but shorter than Charles Lane.)

Charles Lane may not be the shortest street in Manhattan, but it is certainly one of the narrowest. It has no sidewalk and is only fifteen feet wide.

This small street appeared in documents from the late eighteenth century, first as Charles Street—before the current Charles Street got its name—then as Pig Alley and later as Charles Lane. It was laid out in 1797 as a roadway along the north wall of Newgate Prison. Charles Lane wasn't officially mapped out as a New York City street until 1893, nearly one hundred years after it was laid out. Some of the original paving stones from 1893 are still there.

These paving stones, by the way, are often mistakenly referred to as cobblestones, but they are actually "Belgian blocks." Cobblestones are rounded and rather small, whereas Belgian blocks are more rectangular and quite a bit larger. During the Draft Riots of 1863, cobblestones were

referred to as "Irish confetti." But the paving stones on Charles Lane are Belgian blocks, perhaps too heavy to hurl effectively.

Why was Charles Lane called Pig Alley? In all likelihood, it got its name because of the pigs that congregated there in the early 1800s, in the lane that ran alongside Newgate Prison. At that time, there were slaughterhouses along West Street, so perhaps this was where the pigs were kept.

Although some of the old stables and warehouses that lined Charles Lane have been converted to residences (and indeed most of them are now luxury dwellings), Charles Lane still retains its back-alley feeling. You can still recognize the premises of our friends Beadleston & Woerz, who used 8A–F as a freight depot for their brewery. Just around the corner,

159 Charles Street.

159 Charles Street was also owned by the brewery and used as housing for Beadleston & Woerz workers.

In fact, Beadleston & Woerz owned a number of buildings on Charles Street, but 159 is distinctive in that it is one of the few surviving row houses from the 1830s. It was built in 1838 for Henry Wyckoff, a merchant who never lived there. He leased it to James Hammond, descendant of Elijah Hammond, who owned another piece of Sir Peter Warren's property. Hammond Street, which later became West Eleventh Street, was named for Elijah, not James. (And there's a Wyckoff Street and a Wyckoff Avenue in Brooklyn, perhaps the same family as Henry?)

Henry Wyckoff (b. 1768) was a businessman, a politician and a real estate investor. The building at 159 Charles Street was one of the nine lots that Wyckoff purchased when the Newgate Prison grounds were auctioned. He built six houses on his property, of which 159 Charles Street is the only one that remains. The neighborhood at the time was very mixed; commercial, residential and industrial buildings stood side by side. There was an ice depot next door to 159 and right across the street was a coal yard. Henry Wyckoff also built a steel factory in Charles Lane that has since disappeared.

Back to Charles Street. Serving as the headquarters of the Ninth Precinct of the New York Police Department between 1897 and 1971 was 135 Charles Street, just up the street from Wyckoff's building. An elaborate Beaux-Arts-style building, it was converted into apartments in 1978, appropriately called Le Gendarme Apartments. If you look up, you can see the word "POLICE" cut into stone on the pediment and "Police Patrol" over two of the windows. The Ninth Precinct moved to 233 West Tenth Street and is now the Sixth Precinct.

Across the street from Le Gendarme Apartments, at 132 Charles Street, is the oldest surviving structure in the waterfront area, an 1820 row house. One of the few remaining wood-frame houses in Manhattan, it now has a stucco façade.

There were many warehouses in the streets around the waterfront in the nineteenth century, including the Shepherd Warehouse building at 277 West Tenth Street (converted to Shepherd House Apartments in 1974) and the Tower Warehouse on Greenwich Street between Charles and Perry Streets (yes, also apartments these days), both still largely intact. The Tower Annex, at 127 Charles Street, near Greenwich Street,

132 Charles Street.

Tower Apartments, 726–36 Greenwich Street.

was also converted to apartments in 1974, but the exterior remains unchanged. And right next door, at 129 Charles Street, is one of many old stable buildings; this one is notable for the horse's head protruding just above one of the third-story windows.

At the corner of Charles and Greenwich Streets, we come to a house with its own special history—121 Charles Street, also known as Cobble Court. Built in 1809, Cobble Court was a farmhouse originally located on the corner of what is now York Avenue and East Seventy-first Street, in the Upper East Side of Manhattan. A two-story brick building was constructed directly in front of the farmhouse in 1869, which effectively hid it from view. It was generally forgotten and neglected for one hundred years, except, as you will see, by some local residents.

In 1966, tenants of the farmhouse, which had been renovated and updated in the 1950s and now had plumbing, electricity and running water, learned that it was scheduled for demolition to make way for the Mary Manning Walsh Nursing Home. In order to save it from destruction, a petition was presented to the City of New York for permission to move the house to another location. With the help of Mayor John Lindsay and Borough President Percy Sutton, permission was granted, and the entire house, plus the cobblestones that paved its courtyard, were transported to Charles Street. The building, sadly, was renovated too many times in subsequent years to retain any of its original character, thus excluding it from landmark status.

When it was still in its Upper East Side location, the name "Cobble Court" was given to the farmhouse by children's book author Margaret Wise Brown, who rented the house as a writing studio during the 1940s.

Margaret Wise Brown (1910–1952) is a name many of us recognize from our childhood. Born in Brooklyn, she started writing children's books while working at the Bank Street College of Education in Greenwich Village in the 1930s. Her first book, *When the Wind Blows*, was published by Harper and Brothers in 1937. During the remaining years of her short life, Brown wrote more than one hundred books, including some of the classics of children's literature: *The Runaway Bunny* (1942), *The Little Island* (1946), *Goodnight Moon* (1947) and *The Color Kittens* (1949). These and numerous other titles are still in print, many with their original illustrations. Brown is still one of the best-selling children's book authors of all time. *Goodnight Moon*, for example, sold over four million copies between 1970 and 1990.

But Brown's private life was also a bit of a story. Among her romantic relationships were the prince of Spain, Juan Carlos, and James Stillman Rockefeller Jr., to whom she became engaged in 1952. Rockefeller Jr., son of James Stillman Rockefeller, president of National City Bank of New York (which eventually became Citibank), was twenty-six at the time and Brown was forty-two. But they never married. Brown died suddenly, a few months later, during a book tour in France.

In the years between her relationship with the prince of Spain and her engagement to Rockefeller Jr., Brown was romantically involved with Michael Strange, a poet and playwright. Strange (1890–1950) was the pseudonym of Blanche Oelrichs, who had been married to John Barrymore between 1920 and 1925 and was in the middle of her third divorce when she and Brown met. They lived together at 10 Gracie Square until Michael Strange died in 1950. (Two of Michael Strange's poetry collections are still available: *Poems by Michael Strange* (1919) and *Selected Poems* (1928), as well as a book with the curious title *Resurrecting Life: Michael Strange; with Drawings by John Barrymore*, published in 1921.) Shortly after Strange's death and just before her own, Brown met Rockefeller Jr.

It was during her years with Strange that Brown rented the hidden and unheated cottage that she named Cobble Court. Although Brown worked at Cobble Court for several years, the building was not transported to Charles Street until fourteen years after her death. She did, however, live on West Tenth Street during her years at the Bank Street College but spent the last two decades of her life on the Upper East Side.

Cobble Court at 121 Charles Street is barely recognizable today. But if you look closely, on the left side of the building you'll see a birdhouse, which is a replica of the original nineteenth-century farmhouse.

When Cobble Court was moved to its current location, it displaced a converted stable, which was, at that time, the home of photographer Diane Arbus (1923–1971). She lived at 121½ Charles Street from 1959 to 1968. Arbus's story is well known. An extraordinary photographer who took her own life at the age of forty-eight, Arbus was widely acclaimed during her lifetime. Her reputation continues to grow.

Many of Arbus's images have become a familiar part of the American photographic canon. Known for her disturbing portraits of mentally (and otherwise) disabled people, her work remains controversial in content but not in quality.

Cobble Court birdhouse.

A student of Berenice Abbott and Lisette Model, Arbus started her career as a commercial photographer. She and her husband, Allan Arbus, were both fashion photographers who worked as partners between 1946 and 1956. It is her work from 1956 onward that brought Diane Arbus international recognition. The recipient of two Guggenheim fellowships (1963 and 1966), her photos were first exhibited at the Museum of Modern Art in New York in 1967. Four years later, and one year after her death, a retrospective of her work was mounted by the Museum of Modern Art and traveled around the United States and Canada for three years. In subsequent years, there have been many other major retrospectives and numerous books that have been written about her life and her work.

Shortly after her home on Charles Street was demolished to make way for Cobble Court, Arbus moved to Westbeth (West and Bank Streets), where she died. Her work has been seen by millions worldwide, and she is considered one of the most important photographers of the twentieth century.

ONWARD DOWN CHARLES STREET

Writers, Musicians and a Future Mayor

Charles Street has had more than its share of illustrious inhabitants coming and going through the years, some living here only briefly, in a single room or shared apartment, years before their glory days.

One chronicler of the mid-twentieth-century Greenwich Village scene was Holly Beye, who lived at 120 Charles Street between October 1949 and October 1950. A journalist, poet, playwright and civil rights activist, Beye kept a journal of her year in the Village, which disappeared and resurfaced fifty years later. It was published in 2006 as *120 Charles Street, The Village: Journals and Writings 1949–1950* (Huron, OH: Bottom Dog Press).

Beye and her husband, artist David Ruff, lived in a one-room, thirty-dollar-a-month basement apartment. They entertained other young writers and artists such as Kenneth Patchen and James Baldwin, who lived in this cheap and impoverished but very friendly part of Manhattan.

Born in 1922, Beye's first job in New York was as a guard at S. Klein's Department Store on Fourteenth Street. (Those of us of a certain age remember Klein's very well, if not fondly.) During her Charles Street sojourn, she lived on unemployment insurance and part-time work in a bookstore. Beye, Ruff and their large circle of friends spent a lot of time at the White Horse Tavern, years before it became a fashionable literary watering hole. (We'll stop by at the White Horse a little later on, in Chapter 8.)

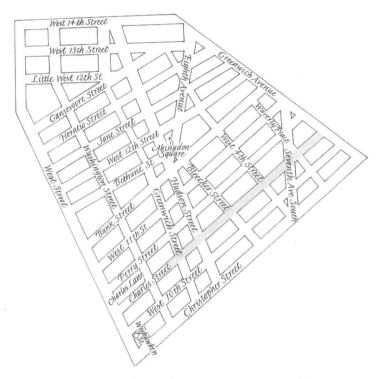

120 Charles Street.

Onward Down Charles Street

After a year on Charles Street, Beye and her husband moved to San Francisco, and the journals were forgotten. In later years, Beye's writings—often politically and socially conscious—were published, and her plays were produced. Her New York journals, however, tell of a time when life in the West Village was simple.

A couple of blocks farther east, we come to 79 Charles Street, located between Bleecker and West Fourth Streets. (Now here's something odd: for that one block, between Bleecker and West Fourth Streets and *only on the north side of the street*, Charles Street had a different name. It was called Van Nest Place until 1936, when it became Charles Street to conform to the rest of this seven-block street. What is now 79 Charles was 15 Van Nest Place when poet Hart Crane lived here in 1920.)

Hart Crane (1899–1932) lived a short and unhappy life. Born in Ohio, he was the son of a candy manufacturer who made his fortune on chocolate bars. The owner of the patent to Life Savers, Crane's father unfortunately (for himself) sold it before Life Savers took off commercially. Crane came to New York at the age of eighteen to write but was tormented by guilt about his homosexuality, as well as by alcoholism. During his lifetime, two books of his poetry were published, one of which, *The Bridge* (1930), a book-length poem, is considered one of the most significant poetry books of the twentieth century despite its density and complexity. (Tennessee Williams was quoted as saying, to paraphrase his words, that he loved the book but couldn't understand it!)

Crane lived at 79 Charles Street for only one year. After the publication of *The Bridge*, Crane spent 1931–1932 in Mexico on a Guggenheim fellowship and, on the way home, committed suicide by jumping overboard into the Gulf of Mexico. His body was never recovered.

A few years before Crane lived on Charles Street, another literary figure resided on the same street. The building at 69 Charles Street—10 Van Nest Place at the time of our story—was the home of the young Sinclair Lewis (1885–1951). He lived there between 1910 and 1913, several years in advance of his great success as a novelist.

Like Crane, Lewis was born in the Midwest and came to New York early in his writing career. While living in a small room on Charles Street, Lewis earned $12.50 a week reading manuscripts for a publisher and wrote short stories for popular (mainly pulp) magazines.

Lewis hit the big time a few years after he left New York. His first big success was *Main Street* (1920), which sold millions of copies and made him a very rich man. Subsequent novels included *Babbitt* (1922); *Arrowsmith* (1925), for which he was awarded the Pulitzer Prize (which he refused); *Elmer Gantry* (1927); and *Dodsworth* (1929). In 1930, Lewis became the first American to win the Nobel Prize for Literature (which he accepted).

Lewis's novels mostly express a jaundiced view of the American dream. Critical of American values and standards, their point of view may well be applicable to contemporary life. Although not generally in vogue today, a number of Lewis's novels were made into films that are considered Hollywood classics.

He died in 1951 of the effects of a lifetime of alcoholism.

Our walk along Charles Street now takes us from the world of literature to that of folk music, one of the "scenes" most closely associated with Greenwich Village since the 1940s.

And who better to represent that world than Woody Guthrie (1912–1967)? One of his New York addresses was 74 Charles Street, where he lived in 1943.

Guthrie was already a well-known folk singer and songwriter by the time he arrived in New York in 1940. He had traveled across the country from Oklahoma, his birthplace, to California with migrant workers during the Depression and had collected folk and blues songs during his wanderings. He continued to crisscross the country in subsequent years but spent the early years of the 1940s as a member of the Almanac Singers, a folk music and protest-song group who had their home base in Greenwich Village. The Almanac Singers, who took their name from *The Farmers Almanac*, lived communally in various apartments, including one at 130 West Tenth Street, around the corner from the apartment that Woody Guthrie was to occupy a couple of years later.

Calling their home "Almanac House," the group of musicians earned their rent money by offering informal concerts in the basement of the building, charging their audience thirty-five cents per person. In addition to Guthrie, Pete Seeger, Bess Lomax (sister of Alan Lomax) and Lee Hays were members of the Almanac Singers, as well as several others who played with them occasionally.

Onward Down Charles Street

The Almanac Singers didn't last long. Their left-wing/socialist/labor movement inspired songs ultimately led to serious difficulties, including an investigation by the FBI, accusations in the press and suppression of some of their recordings. The group disbanded during the Second World War, but re-formed in 1950 as the Weavers, whose music was perceived as somewhat less radical—and consequently more widely accepted—than that of the Almanac Singers.

It was during the Almanac years that Woody Guthrie wrote "This Land is Your Land," probably the most universally familiar of his hundreds of songs. The story goes that Guthrie wrote "This Land is Your Land" in protest against "God Bless America," which was constantly being played on the radio. The original lyrics of Guthrie's song, some of which tend to be omitted in concerts and recordings, are politically charged, and include the line, "*Is* this land made for you and me?"

Before we leave Charles Street, let's make two more stops, first at 39, where Fiorello LaGuardia lived between 1914 and 1921.

Who doesn't know the name LaGuardia? Probably the most famous (and perhaps the best) New York City mayor ever, LaGuardia was still a young, unmarried attorney when he moved to Charles Street. By 1916, he was a member of the United States House of Representatives, where he served until 1918 and then again between 1922 and 1930. In 1934, LaGuardia was elected mayor of New York, the first of three terms. He left office in 1945.

A loud, energetic, colorful figure, LaGuardia came from an Italian immigrant background, with a lapsed Catholic father and a Jewish mother, so one could say that he was the first Italian mayor of New York, as well as the first Jewish mayor of New York! A progressive, liberal Republican, he was also the candidate of the New Deal Democrats, the Socialist Party and the American Labor Party.

LaGuardia is credited with destroying the power of Tammany Hall (the corrupt Democratic political machine), going to battle with organized crime and bringing the city back to life during and after the economic disasters of the Depression. LaGuardia secured sufficient federal funds to revitalize New York City, and along with parks commissioner Robert Moses, built public housing, parks, bridges, tunnels, highways and two airports, one of which now bears his name. His support of, and by,

Franklin Delano Roosevelt helped make many of these public works projects financially viable.

In his fight against racketeering and organized crime, Mayor LaGuardia went after Lucky Luciano, among other crime bosses, and was quoted as saying, "Let's drive the bums out of town."

And speaking of crime, a farther stop on Charles Street is the home of crime fiction writer James Cain (1892–1977). He lived at 11 Charles Street, almost at the eastern border of the Original West Village, between 1925 and 1927.

Like the other writers whose former homes we've stopped to look at, Cain lived here several years before he achieved success as a novelist. (It is interesting to realize that for more than half of the twentieth century, Greenwich Village was a neighborhood you moved *out of* when you had enough money; in recent years, when you can afford to, you move *into* the Village!)

Cain's first novel, written after he left New York, *The Postman Always Rings Twice* (1934), was a bestseller, as were *Double Indemnity* (1936) and *Mildred Pierce* (1941). These are considered classics of their genre: tales of sex, violence and crime. Many of Cain's novels and two short-story collections are available today, some with particularly lurid covers (e.g., *Sinful Woman* and *The Baby in the Icebox*).

During the 1940s, several of Cain's novels were made into movies and perfectly represent the era of Hollywood film noir.

Unlike several other residents of Charles Street, Cain lived a long life and kept writing until his death at the age of eighty-five. And like Sinclair Lewis, we may not read his novels all that often, but who hasn't seen the films?

Before we leave Charles Street, we should pay homage to one more American writer who lived here briefly in 1947.

The son of an illiterate sharecropper, Richard Wright (1908–1960) was born on a plantation in Natchez, Mississippi. Unable to finish high school, Wright left home and lived in Memphis and Chicago, where he joined the Communist Party in 1933, before coming to New York City in 1937 and becoming the Harlem editor of the *Daily Worker*.

His first short-story collection, *Uncle Tom's Children*, which, like much of his writing, focuses on the experience of black Americans, was

published to much acclaim in 1938. Two years later, Harpers published *Native Son*, the first bestselling novel by an African American writer; 215,000 copies were sold during the first three weeks after publication. Wright's autobiography, *Black Boy* (1945), and numerous other fiction and nonfiction works have established his reputation as one of the most important American writers of the twentieth century.

But his life was not easy. Despite critical and financial success, Wright's life was plagued by racism. His membership in the Communist Party—which he renounced in 1944 and later wrote about in *American Hunger*, published posthumously in 1977—was also complicated by racism; his literary success was deemed bourgeois, and he was accused of selling out to the white establishment. (Outspoken in his views, Wright was criticized throughout his life, no matter which side of the political spectrum he supported.)

Fed up with American racism and threatened by McCarthyism, Wright left New York in 1947 and immigrated to France. He never returned to the United States. But shortly before his departure, Wright purchased a building at 13 Charles Street and lived there briefly with his family. The building has since been demolished and replaced by the eighteen-story Village Towers.

Chapter 7

PERRY STREET

Frank Serpico, Jane Jacobs, Sir Peter Warren and Bleecker Gardens

We have met the enemy and he is ours," said Commodore Oliver H. Perry, naval hero of the War of 1812. And here we are on Perry Street, named in his honor. Perry Street is one block north of Charles Street and runs from one end of the Original West Village to the other, from Greenwich Avenue to West Street.

There are a couple of big stories associated with Perry Street, one of which has captured worldwide attention, thanks in part to the global reach of Hollywood. And that is the history of Frank Serpico, who lived in a small garden apartment at 116 Perry Street, between Hudson and Greenwich Streets, during the 1960s.

Serpico, born in Brooklyn in 1936, joined the New York Police Department in 1959 after serving in the U.S. Army in Korea. A young man of high principles, Serpico strongly objected to the corruption and bribery that he encountered within the police department. After many fruitless attempts to bring the situation to the attention of his superiors in the department, as well as city hall, Serpico finally went public. In April 1970, he told his story to the *New York Times*, and it made front page news.

What followed is well known. New York City mayor John Lindsay appointed Judge Whitman Knapp to head a commission to investigate police corruption. Frank Serpico's testimony before the Knapp Commission—officially known as the Commission to Investigate Alleged Police Corruption—resulted in criminal indictments from

Perry Street

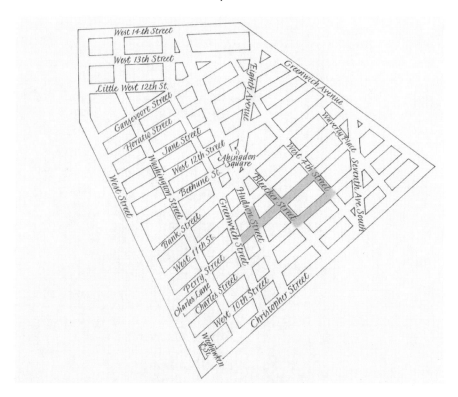

116 Perry Street.

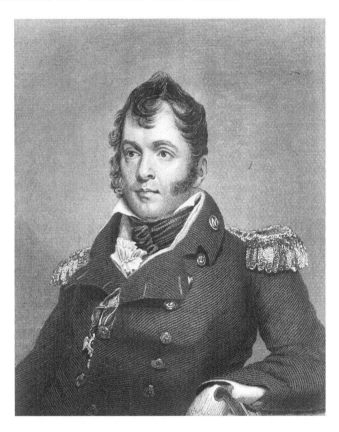

Commodore Oliver H. Perry. *Courtesy of the Library of Congress, Prints & Photographs Division, photograph by Harris & Ewing.*

the top down, the resignation of the police commissioner and major reforms at all levels.

The result for Serpico, not surprisingly, was the anger and hostility of his colleagues, which made him a virtual outcast. Following the hearings, Serpico continued to work as a police officer—but not for long. Shortly after his 1971 testimony to the Knapp Commission, he was shot in the face during a heroin bust in Brooklyn. The possibility that he was set up by his fellow police officers, and that they took too long to come to his aid, has been voiced more than once. Grievously wounded, he left the police force, and when he recovered from his injuries, spent many years traveling and studying before settling in a one-room cabin in an undisclosed location in upstate New York.

The story of Frank Serpico, the New York Police Department and the Knapp Commission is a familiar part of New York City history, thanks to Peter Maas's bestselling book, *Serpico* (New York: Viking Press, 1973),

555 Hudson Street.

which sold more than three million copies, and perhaps even more so to the movie, *Serpico*, which made both Frank Serpico and Al Pacino household names. The film was nominated for an Academy Award and garnered Al Pacino his first Golden Globe Award. The location of Serpico's Manhattan apartment in the movie, however, was Minetta Lane, farther south in Greenwich Village, not Serpico's actual Perry Street address.

At the same time that Frank Serpico was living on Perry Street, another soon-to-be-well-known figure had an apartment just around the corner, at 555 Hudson Street, between Perry and West Eleventh Streets. Jane Jacobs may not have achieved the notoriety of Frank Serpico, but she was one of the most important names in urban planning and the preservation of city neighborhoods in the twentieth century. It may sound a little abstract and more than a little academic to those of us who are not in the field of urban planning, but the shape and texture of Greenwich Village and indeed New York City owes a lot to the ideas advocated by Jacobs.

Born Jane Butzner in 1917, Jacobs's life spanned most of the twentieth century (she died in 2006 at the age of eighty-nine). She came to New York City from her birthplace in Scranton, Pennsylvania, at the age of

seventeen during the Depression and lived briefly in Brooklyn Heights before moving to the West Village, where she stayed for the next thirty-four years. Married in 1944, Jacobs and her family left the country in 1968, partly in protest against the Vietnam War and partly to protect her sons from the draft. She spent the rest of her life in Toronto.

A writer, activist and keen observer of city life, Jacobs was an outspoken critic of the urban renewal policies of the 1950s, which called for the destruction of small-scale clusters of houses and shops, replacing them with anonymous towers and open urban spaces. In her widely acclaimed book, *The Death and Life of Great American Cities*, published by Random House in 1961, Jacobs presented powerful arguments against urban renewal projects that would destroy the life of city neighborhoods. Four subsequent books and numerous published articles detailed her theories of urban development, urban design and economics. Her critique of existing policies and systems caused tremendous controversy among city planners, architects, journalists and academics, who continue to argue for and against her point of view.

An activist as well as a writer, Jacobs served as chair of the Joint Committee to Stop the Lower Manhattan Expressway and played a major part in a similar movement in Toronto, blocking the Spadina Expressway, which would have cut through the center of the city. Successful in both campaigns (neither highway was built), Jacobs was arrested more than once and went head to head with Robert Moses, ultimately preventing the construction of the Lower Manhattan Expressway. (A hero under LaGuardia, some of Robert Moses's later plans and schemes were met with less enthusiasm.)

Jacobs was essentially self-educated. She left Scranton just after high school and never completed any formal higher education. She read widely and studied eclectically, taking classes at Columbia University Extension School and Barnard College. The story goes that her high school grades were too low for Barnard's standards; the college admitted her briefly and then told her she didn't qualify. Jacobs was quoted as saying that being rejected by Barnard gave her the freedom "to continue getting an education."

Jacobs may have spent the second half of her life in Canada, but she is considered one of the great defenders and preservers of New York City and the special character of its neighborhoods. For Jacobs, the view from

her Hudson Street apartment, located on the second floor over a candy store, the streets of Greenwich Village and the street life in which she participated exemplified her ideal of the urban community.

Just one block farther, heading west along Perry Street, is the former location of one of the great historic homes of the West Village, that of the illustrious Sir Peter Warren (1703–1752).

Our visit to Sir Peter's home can only be imaginary, since the building was demolished in 1865, but he and his heirs left many a mark on the map of New York City, and other places as well: Warren, Rhode Island, and Warren, New Hampshire, to name two. There are also Warren Streets in Brooklyn and Manhattan.

Sir Peter's homestead was located between Perry and Charles Streets and between Bleecker and West Fourth Streets. The house, a large square building with two chimneys and a widow's walk, was built on top of a hill, surrounded by the Warren farmland. As mentioned earlier, Sir Peter's estate was huge, comprising three hundred acres from the Hudson River to Fifth Avenue and Third to Twenty-first Streets.

Who was Sir Peter Warren? He was a British naval hero, born in Ireland, who went to sea at the age of thirteen; by the time he was twenty-four, he was a captain. Rapidly rising to vice admiral and later admiral (in 1747), his career with the British navy was both dramatic and perhaps a little shady. He amassed a huge fortune, partly through what was known as the "prize system," a policy that allowed naval officers to profit from the capture of enemy ships. Sir Peter was, in fact, rumoured to be a privateer, a pirate (though never officially so named) in service to the crown. As a captain, he attacked French and Spanish ships, which he plundered for the British but also for his own gain.

Although he may have been a privateer, Sir Peter was also a military hero. He helped capture Louisburg on Cape Breton Island, Nova Scotia, a British victory over the French navy, and was second in command of the British fleet during the Battle of Cape Finisterre in 1747, both of which victories brought him glory, land in the NY colony and lots and lots of money. During the British rule of New York (1664 until the American Revolution), he was the largest landowner in Greenwich Village.

As his fortunes grew, so did Sir Peter's land holdings. In addition to his Manhattan estate, he owned several thousand acres north of the city, near Schenectady.

Sir Peter spent the last years of his life in England, where he was elected to the House of Commons, representing Westminster. He was reputed to be the wealthiest commoner in England and was buried in Westminster Abbey.

Sir Peter's property was inherited by his daughters, one of whom, Charlotte, married the Earl of Abingdon, for whom Abingdon Square is named. We'll be visiting Abingdon Square in Chapter 12. His other two daughters also had streets named after them: Susanna, wife of William Skinner (Skinner Road, now Christopher Street) and Mrs. Charles Fitzroy.

In later years, Abijah Hammond purchased the Warren homestead; Hammond Street, named after him, became West Eleventh Street. The property subsequently became part of Abraham Van Nest's holdings. You may recall that we visited the former Van Nest Place during our stroll down Charles Street.

Let's return to the twentieth century.

A very short walk from Jane Jacobs's apartment, at much the same time as she made her home in New York, lived Mark Van Doren, another remarkable resident of the Original West Village. And it was here, behind a façade of row houses, that Van Doren's Bleecker Gardens was created.

Mark Van Doren (1894–1972), Pulitzer Prize–winning poet, critic, playwright and highly regarded professor at Columbia University, bought a house at 393 Bleecker Street, between Perry and West Eleventh Streets in 1929. He and his neighbors agreed to take down the fences that separated their backyards and share a common space, which became known as Bleecker Gardens. In fact, the garden was a paved courtyard bordered by shrubs and trees, but it was also the gathering place for writers and intellectuals, with Van Doren as the central figure, for nearly thirty years. James Thurber and Lionel Trilling were among the Bleecker Gardens regulars.

Bleecker Gardens still exists, although it is hidden from view. The inhabitants of the houses opening onto the courtyard still contribute to a common fund for its upkeep.

Among the buildings that share the Bleecker Gardens courtyard is one that dates back to 1818. It is the sole remnant of the fifty-five acre Hammond Estate from 1799. (West Eleventh, as we mentioned before, used to be called Hammond Street.)

During his fifty years at Columbia University as a professor of English between 1920 and 1959 and as a professor emeritus until his death in 1972, Van Doren taught many of the most important writers and poets of the twentieth century, numbering among his students John Berryman, Jack Kerouac, Allen Ginsberg and Thomas Merton.

393 Bleecker Street.

Van Doren's poetry anthology, *An Anthology of World Poetry*, published in 1928, brought him fame and sufficient fortune to purchase the house on Bleecker Street that fronts the Bleecker Gardens courtyard. The book is still available, as are numerous volumes of Van Doren's poetry, literary criticism, short stories and his autobiography. Van Doren's *Collected Poems 1922–1938*, compiled from six other collections of his poetry, was awarded the Pulitzer Prize.

But moving from literary history to television scandal, we tend to associate an unfortunate event with the name Van Doren, although it was not Mark Van Doren, but his son, Charles, who was the central figure in this tale. In 1959, during the glory days of television quiz shows (remember *The $64,000 Question?*), it was revealed—to the shock of all of America—that a number of quiz show contestants were being handed the answers to the game show questions in advance. And one of the big winners had been Charles Van Doren. A young instructor at Columbia University, Van Doren had defeated all comers, winning $138,000 on the NBC show *Twenty-One* and charming an enormous television audience. He was also featured on the cover of *Time* magazine and awarded a three-year contract with NBC.

Charles Van Doren, handsome, personable and well spoken, had been selected by one of the show's producers and carefully coached on how to answer, what to say, when to pause and when to speak. Having been told that the television quiz shows were mere entertainment and that being given the answers was a standard practice, Van Doren made his pact with the devil, a decision he would live to regret.

When the scandal broke, wide-sweeping investigations were conducted. Van Doren first denied and later confessed to having cheated. He lost his job at Columbia, as well as his contract with NBC, and moved to Chicago with his wife, where he spent most of the remainder of his working life as an editor for *The Encyclopedia Britannica*.

Like Frank Serpico, Charles Van Doren's story was made into a movie. And, like *Serpico*, *Quiz Show* (1994), directed by Robert Redford, was a big success. Like so much that we read in our history books, the tales of corruption and scandal tend to make the best theater.

On the corner of West Eleventh and Bleecker Streets, just past the former home of the Van Dorens, is a sculpture that we should look at. This is Chaim Gross's *The Family*, and it depicts a circus act of acrobats—two large and three small figures that might be parents and children. Like much of Gross's work, they are joyful figures; the man and woman seem to be spinning around, holding the three small figures aloft.

Gross, who spent most of his life in Greenwich Village, came to the United States from Austria in 1921 at the age of twenty-five and soon gained a reputation as a sculptor. During the Depression, he benefited from the New Deal Public Works Art Project, receiving several commissions for sculptures to decorate federal buildings, which brought his work a lot of attention. During his lifetime, he created a large body of work that is in museums and collections worldwide, as well as in public spaces like the little park on the corner of Bleecker Street. Created in 1979, *The Family* was donated to New York City in 1992 in honor of outgoing mayor Edward Koch.

Like Mark Van Doren, Chaim Gross devoted many decades to teaching. He taught at the Educational Alliance from 1927 until 1989—sixty-two years!

From his early years in New York, Gross was recognized as a major artist. Well known for his generosity, he shared his success with generations of artists and students. Although he spent his early years working in wood,

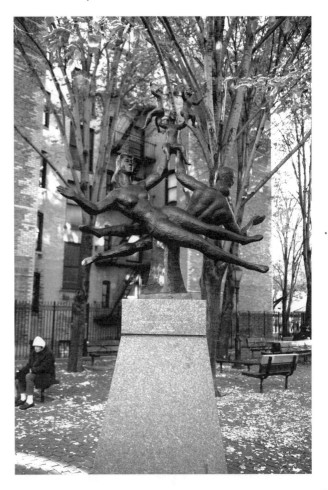

The Family, sculpture by Chaim Gross, Bleecker and West Eleventh Streets.

by the 1950s he switched to bronze (the material of which *The Family* is constructed). His themes were cheerful and upbeat: dancers, acrobats, cyclists, women and children, bringing warmth and good humor to the environment where they are located.

The studio where Gross worked, and where he and his wife lived, has been turned into a museum, the Chaim Gross Studio Museum; it is located just south of the Original West Village, at 526 LaGuardia Place. Administered by the Renee and Chaim Gross Foundation, this free museum houses a large collection of his work and provides support for other artists and museums.

And this brings us to our next stop, a left turn and a short walk down West Eleventh Street to the renowned White Horse Tavern.

Chapter 8

UP AND DOWN
WEST ELEVENTH STREET

The White Horse Tavern, a Palazzo and Many Writers and Poets

It's time for a break. Where better to rest than at one of the last of New York's old-time saloons? The White Horse Tavern, located on the southwest corner of West Eleventh and Hudson Streets, is familiar to local residents, to New York City history buffs and especially to those who are interested in the city's literary past. For large numbers of tourists, the White Horse Tavern is the place where Dylan Thomas was said to have drunk himself to death, which is actually not quite true.

Opened in 1880, the White Horse was originally a longshoremen's bar, situated just three blocks from the waterfront. It was a speak-easy during Prohibition. Located in a modest three-story wood-frame building with a brick facade, the White Horse is divided into a number of small rooms, with wooden floors, dark paneled walls, light fixtures decorated with horses' heads and a long, noisy bar. One has a sense that the décor has remained unchanged for the last century, and it is easy to imagine the place occupied by men in work clothes, drinking whiskey and beer into the night (rather than guide-book toting tourists drinking Diet Cokes and Perrier). Of course the antismoking laws have made the old smoke-filled bar a thing of the past, now replaced by a lively—and smoky—sidewalk café extending onto Hudson Street.

But it's not the booze or the light fixtures that bring the crowds to the White Horse, it's the association with numerous literary and media luminaries. From the 1950s on, in fact starting in Dylan Thomas's day,

Up and Down West Eleventh Street

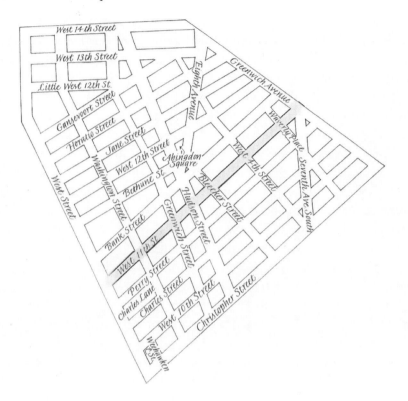

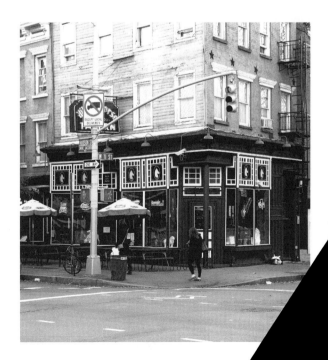

White Horse Tavern,
Hudson and West
Eleventh Streets.

the White Horse has attracted writers, poets, musicians and journalists, many of whom seem to have spent the majority of their waking hours drinking and arguing at the bar.

Dylan Thomas (1914–1953) actually spent very little time in New York. Born in Wales, he started writing poetry as a teenager, and by the time he was twenty, his work had been published and acclaimed in Britain. His first book, *18 Poems*, appeared in 1934. He was admired by some of the most important poets of the day, notably T.S. Eliot, Stephen Spender and Edith Sitwell, and his reputation as an important young poet was quickly established. Interestingly, although he was born and raised in Swansea and is considered one of the foremost Welsh poets, Dylan Thomas never learned Welsh; he wrote exclusively in English.

During his very short and largely alcohol-fueled life, he was also recognized for his powerful and moving poetry readings. *Under Milkwood*, Thomas's most famous work, was written as a radio play, commissioned by the BBC. Started in 1944, Thomas completed it just before his death; it was published posthumously in 1954. Although he toured England and the United States, giving public performances of *Under Milkwood*, he died just two months before he was scheduled to record it for the BBC. We tend to associate *Under Milkwood* with Richard Burton, who made the first of several recordings in 1954, and a film of the play with Elizabeth Taylor and Peter O'Toole in 1972.

Thomas toured the United States three times between 1950 and 1953, giving more than one hundred poetry readings. In 1953, he was scheduled to read in forty university towns throughout the country. This tour never took place.

It is, unfortunately, his drinking that links the name of Thomas to the White Horse Tavern. Although he died in New York City, he spent only the last three weeks of his life here, where he performed *Under Milkwood* at the Poetry Centre, slept at the Chelsea Hotel on Twenty-third Street and spent his evenings at the White Horse. His death, although popularly ascribed drinking bout (or several), was caused by pneumonia and bronchitis drinking surely could not have done him much good).

predictable and very colorful figure, Thomas's tors to both the Chelsea Hotel and the White Horse. s far from the only larger-than-life customer of the rn. The White Horse was also popular with the Beat

poets and writers such as Jack Kerouac, Allen Ginsberg and Gregory Corso. In fact, Kerouac is reputed to have been one of the less welcome patrons and was frequently thrown out.

Jack Kerouac (1922–1969) spent some time right across the street from the White Horse, at 307 West Eleventh Street, where he revised *On the Road* and wrote part of *Desolation Angels* while staying at his girlfriend's apartment.

Other major literary figures included Jane Jacobs, who mentioned the tavern in *The Death and Life of Great American Cities*; James Baldwin; Michael Harrington; Ezra Pound; Anais Nin; and Hunter S. Thompson. Among the musicians known to have frequented the White Horse were Bob Dylan, Mary Travers, Richard Farina and Jim Morrison.

An interesting chapter in the history of the White Horse Tavern is that of the birth of the *Village Voice*, Greenwich Village's newspaper, which some say was conceived at a table at the White Horse (other histories report that it originated in an apartment in Greenwich Village). Be that as it may, Norman Mailer, one of the founding forces in the creation of the *Village Voice*, was a regular at the White Horse, and the newspaper may well have been a hot topic of conversation for Mailer and the paper's cofounders, Ed Fancher and Dan Wolf, in the mid-1950s.

The *Village Voice* has been around since 1955, originating as an alternative newspaper, the focus of which was limited to Greenwich Village. Within a few years, it expanded its coverage to New York City and national politics, with award-winning investigative journalism and columns on the arts, music and theater, while maintaining its antiestablishment point of view and "underground" sensibility. The list of contributors has been stellar, but today the *Voice* is owned by a conglomerate, and the names one once associated with the *Village Voice* (writers Nat Hentoff, Robert Christgau, J. Hoberman, John Wilcox, Peter Schjeldahl, Richard Goldstein and many others, plus cartoonists Jules Feiffer, R. Crumb, Stan Mack, Matt Groening and more) are now part of its history.

Norman Mailer (1923–2007) wrote a column for the *Voice* for only a few months, but his name is central to the literary and political history of twentieth century America. Like Dylan Thomas, he was a colorful character, prodigiously talented and enormously successful, but unlike Thomas, Mailer had eighty-four years to make himself known (for better

or for worse). Had he died young, he would still be part of the American literary canon; *The Naked and the Dead*, published in 1948, is considered one of the great World War II novels.

Mailer's list of fiction and nonfiction books is long. His writing was often controversial, as was his journalism. Winner of two Pulitzer Prizes and the National Book Award—*The Armies of the Night* (1968) won both—one associates his name with political activism, the New Journalism and a particularly turbulent personal life. Married six times, Mailer was arrested in 1960 for stabbing his second wife, for which he received a suspended sentence. He was considered provocative and combative but also a charismatic and compelling figure. He ran for mayor of New York on the Democratic ticket in 1969 (unsuccessfully), calling for the secession of New York City from New York State and the creation of the city as the fifty-first state.

There are many more stories to be told about Norman Mailer, but perhaps it's time to leave the White Horse and see what else happened on West Eleventh Street.

Heading west in the direction of the river, we come to the house where novelist Carson McCullers (1917–1967) lived in 1940, at 321 West

321 West Eleventh Street.

Eleventh Street. This 1838 apartment building looks much the same as it did when she lived here.

McCullers came to New York from her birthplace in Georgia when she was seventeen, planning to study music at Julliard, but that never happened. Like Dylan Thomas and Norman Mailer, she was an early success, publishing *The Heart is a Lonely Hunter* in 1940 and *Reflections in a Golden Eye* a year later, both before she turned thirty. (The film *Reflections in a Golden Eye*, made by John Huston in 1967, starred Marlon Brando and Elizabeth Taylor.) But her life was sad, and like many other authors we have encountered on our walk through Greenwich Village, she suffered from illness, depression and alcoholism.

McCullers—born Lula Carson Smith—married Reeves McCullers in 1937, divorced in 1941 and married him again in 1945. She attempted suicide unsuccessfully in 1948, but her husband succeeded in doing so in 1953. Carson McCullers spent her final years in Paris, where she numbered among her friends Tennessee Williams and Truman Capote.

On a brighter note, as we continue along West Eleventh Street in the direction of the river, we'll come upon the Palazzo Chupi at 360 West

Palazzo Chupi, reflected in windows of 166 Perry Street.

Eleventh Street, between Washington and West Streets. And "bright" is indeed the word. The Palazzo Chupi is hard to miss. Designed by artist/ filmmaker Julian Schnabel, the Palazzo Chupi is an extension upward of the old, three-story former stable building that has been his home and studio for a number of years. The 110-foot tower—including the original three floors, the building rises to 170 feet—with its Italian inspired architectural design, is painted pink (officially "Pompeii red") and is one of the tallest buildings in the neighborhood. Plans for the Palazzo Chupi provoked angry protests on the part of Village preservationists, who called it "a monument to greed," but were not able to prevent its construction.

Completed in 2008, the Palazzo Chupi was described in real estate listings as "a timeless masterpiece" but elsewhere condemned as "a tower of insanity." It has created a lively buzz on a number of Internet sites.

The Palazzo Chupi was conceived as a real estate investment. In addition to Schnabel's private space in the original three-story structure, it contains five residential units: two one-floor apartments, two duplexes and a triplex, all lavishly appointed with luxurious details and some eighteen-foot ceilings. The asking prices for the duplex and triplex apartments in 2008 were breath taking—$27 million and $32 million respectively—but the economic downturn (bad timing!) sent the prices plummeting to $19 million and $22 million in 2009 and subsequently as low as $13 million and $15 million. Sales have not been vigorous. At the time of this writing, one of the duplexes is being offered as a rental apartment for a mere $40,000 a month and the triplex for $50,000.

But to the casual wanderer through the Original West Village, the Palazzo Chupi is certainly worth a momentary pause, reminding us that New York is a city where anything is possible.

Right next door to the Palazzo Chupi, and in striking contrast to it, is a New York City landmark, the William B. Fash house. Fash and his wife, Frances, acquired the property in 1841 after a fire in the Baurmeister & Sheplin Soap Factory destroyed fifty buildings on the block. Fash bought the land for $2,250 and erected a row house with a red brick front and a brownstone base. It is still standing here. Fash and his wife stayed only one year; they lost the house in foreclosure in 1843, but the name hasn't changed.

When the William B. Fash house was built, West Eleventh Street was still called Hammond Street, and so it remained until 1865. The original

William B. Fash house, 354 West Eleventh Street.

address was 144 Hammond Street, and the soap factory was located at 160 Hammond.

We have two more stops to make before we leave West Eleventh Street.

Heading back east, a block or so past the White Horse Tavern is the house where novelist Thomas Wolfe (1900–1938) lived from 1927 to 1928. Wolfe, like Dylan Thomas, achieved success while still in his twenties but, alas, died very young. His first two novels, *Look Homeward,*

Mulry Square, "Tiles for America" installation.

Angel and *Of Time and the River*, were both published by C. Scribner's Sons, in 1929 and 1935, respectively. Wolfe's editor at Scribner's was the renowned Maxwell Perkins, who also worked with F. Scott Fitzgerald and Ernest Hemingway. Wolfe wrote two other novels, *The Web and the Rock* and *You Can't Go Home Again*, both of which were published posthumously, and dozens of short stories.

Wolfe lived at 263 West Eleventh Street while finishing *Look Homeward Angel* and teaching English at New York University.

The last stop on West Eleventh Street is right at the edge of our map. Mulry Square is actually a triangle, bordered by West Eleventh Street, Seventh Avenue South and Greenwich Avenue. It was named for Thomas M. Mulry, a banker and philanthropist who died in 1916. At the dedication of Mulry Square on June 27, 1920, Archbishop Patrick J. Hayes praised Mulry as "a God-fearing saint and apostle of charity."

At one time, Mulry Square was the site of a diner that may have been the inspiration for Edward Hopper's painting, *Nighthawks*. Today the square—or triangle—is used as a fenced-in parking lot, but it is also the location of a memorial to the victims of September 11, 2001. Six thousand tiles donated from across America and as far away as Europe and Japan are affixed to the Mulry Square fence. The memorial, entitled "Tiles for America," was initiated by local ceramic artists immediately following September 11 and now extends more than a city block.

Chapter 9

BUSY BANK STREET

One block north of West Eleventh Street is Bank Street, which we mentioned earlier as the destination of the Bank of New York during the 1798 yellow fever epidemic. The bank remained at that location for a year or so before returning to lower Manhattan, but the name of the street stuck; it became official in 1807. In fact, the Bank of New York built several houses along Bank Street—numbers 16 to 34—that it sold in 1834.

What happened on Bank Street? Quite a lot. Since we ended our West Eleventh Street walk at Mulry Square, at the eastern boundary of the Original West Village, let's walk down Bank Street from east to west.

The block between Greenwich Avenue and West Fourth Street was home to a remarkable number of writers, all living on the north side of the street (but not all at the same time). For a start, Willa Cather (1873–1947) lived at 5 Bank Street from 1913 until 1927, while writing some of her most successful novels: *The Song of the Lark*, published in 1915, *My Antonia* (1918) and *Death Comes for the Archbishop* (1927).

Born in Virginia—her first name was actually Wilella—Willa Cather spent much of her childhood in Nebraska. Although she lived in big cities throughout most of her adult life, Cather's novels mainly concern themselves with life on the Great Plains. She left Bank Street when her building was scheduled for demolition to make way for the construction of the Seventh Avenue IRT.

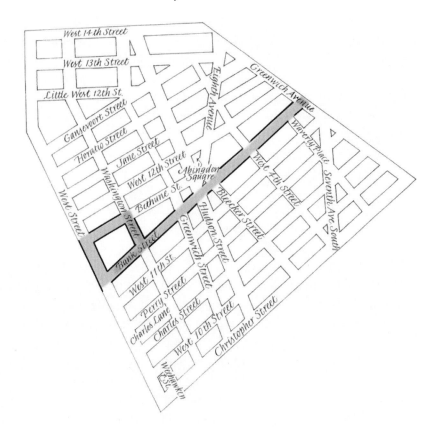

A Pulitzer Prize winner and widely acclaimed (and very successful) novelist, Cather was elected to the American Academy of Arts and Letters in 1938 and inducted into the National Cowgirl Hall of Fame in 1986. The National Cowgirl Museum and Hall of Fame, located in Fort Worth, Texas, also numbers among its honorees Annie Oakley, Patsy Cline, Laura Ingalls Wilder and Sandra Day O'Connor.

The building at 5 Bank Street was later replaced by another one where crime novelist Patricia Highsmith lived in the late 1930s.

On the same block, in fact a few doors down, stands 11 Bank Street, where John Dos Passos lived briefly from 1924 to 1925. Dos Passos (1896–1970) was one of the "Lost Generation" of writers who emerged following World War I. His books were heavily influenced by his political beliefs that swung from far left in his youth to conservative right in his later years. *Manhattan Transfer*, published in 1925, was his third novel and is about New York City, where he had been living since 1917. Dos

Passos's literary peak was probably achieved in the '30s when the *USA* trilogy was published (*The 42ⁿᵈ Parallel, 1919* and *The Big Money*). The trilogy is a fine example of Dos Passos's experimental structure of the novel, combining poetry, prose, newspaper articles and biography to tell his stories. He spent a number of years in New York City but only one year on Bank Street.

Allen Tate (1899–1979) was another Bank Street writer. A most illustrious man of letters during his lifetime, though perhaps no longer a household name, Tate was a poet, critic, essayist, novelist, memoirist and translator. Like so many twentieth-century writers, Tate migrated to New York from the South. He lived in a basement apartment at 27 Bank Street from 1924 until 1928.

During his years in New York, he supported himself as a freelance writer and editor, working for, among others, the *Nation*, the *New Republic* and the publisher of pulp romances; in addition, in order to offset his rent, he was the janitor in the building where he and his wife lived.

In 1928, Tate published his first poetry collection, *Mr. Pope and Other Poems*, which included a version of his best-known poem, "Ode to the Confederate Dead." A Southerner at heart, Tate wrote biographies of Stonewall Jackson and Jefferson Davis and started but never completed a biography of Robert E. Lee. His New York circle included Ford Madox Ford, Hart Crane (we met him on Charles Street), Edmund Wilson, Malcolm Cowley and Kenneth Burke. In later years, he befriended Ernest Hemingway, Gertrude Stein and T.S. Eliot, as well as many other contemporary writers, poets and critics, some of whose work he edited.

And just across the street from 27 Bank Street, we come to 34. It is here that Charles Kuralt (1934–1997) lived for a number of years, although he and Allen Tate never met; Tate left New York six years before Kuralt was born.

Charles Kuralt is a name that is well known across the United States. A journalist and television personality—writer, correspondent and host—Kuralt got his start in his home state of North Carolina, where he contributed a daily column to the *Charlotte News*. His column, entitled People, described the lives of everyday citizens and earned him the 1956 Ernie Pyle Memorial Award and a job in New York at CBS.

Busy Bank Street

34 Bank Street.

Kuralt spent thirty-seven years at CBS, starting by rewriting cables for radio news and soon moving on to television, as a reporter and foreign correspondent and, perhaps most famously, as writer and producer of "On the Road."

"On the Road" was Kuralt's remedy for the cutthroat work of the daily reporter. For twenty-five years, he and a two-man crew roamed the back roads of America, producing human-interest stories about unknown corners of American life, such as seashell collectors, rodeo riders, bagel bakers and the owner of the world's largest ball of string. During its years on television as a weekly segment of the *CBS Evening News with Walter Cronkite*, "On the Road" told five hundred tales gleaned from more than one million miles on the road. Kuralt and his team eschewed the major highways and lived in a succession of motor homes.

Kuralt anchored several other CBS shows, including *Eyewitness News* and *CBS News Sunday Morning*, which he hosted between 1979 and 1994. He was awarded eleven Emmys and three Peabody Awards.

And that's not all; we are still on the very same Bank Street block, between West Fourth Street and Greenwich Avenue, where not one but two publishing companies were founded.

Number 9, the home of James Laughlin (1914–1997), was also the birthplace of the New Directions Publishing Corporation, founded in 1936 when Laughlin was only twenty-two. According to the New Directions website, Laughlin started the press on the advice of Ezra Pound who, after reading Laughlin's poetry, advised him to find something useful to do with his life.

From its inception, New Directions published poetry anthologies, introducing, among others, William Saroyan, Marianne Moore, Wallace Stevens and Dylan Thomas. In later years, New Directions is credited with assuring that the work of many important and sometimes controversial novelists, playwrights and poets remain in print, including Henry Miller, Evelyn Waugh, William Carlos Williams, Ezra Pound and F. Scott Fitzgerald. Still a force in the publishing world, New Directions, along with its founder, Laughlin, has received numerous awards and honors.

A few doors down from Laughlin's residence, the important—if short-lived—Golden Stair Press got its start at 23 Bank Street, in the apartment of Prentiss Taylor. Taylor (1907–1991) was a painter and lithographer who illustrated some of the poetry of Harlem Renaissance poet and playwright Langston Hughes (1902–1967). Carl Van Vechten, a successful photographer and critic, loaned Taylor $200 to start the Golden Stair Press, which published the work of Hughes and other socially conscious poets and artists in the early 1930s. The press operated out of Taylor's Bank Street apartment, where books and hand-colored broadsides were printed. Due to financial difficulties, the Golden Stair Press folded a few years later.

Hughes was still at the start of his career when Taylor published his work; his subsequent achievements are part of American literary and theatrical history.

Moving along, we're going to walk past the house where Sid Vicious died of a heroin overdose in 1979 (63 Bank Street) and stop at 69, the former Fleischman's Yeast Brewery and storage building, that was acquired in 1930 by the Bank Street School for Children (now called the Bank Street College of Education).

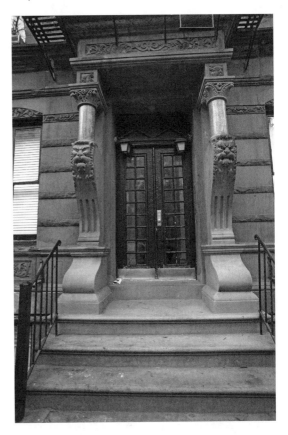

63 Bank Street.

The Bank Street School, well known in the annals of progressive education, had its origins in 1916 when the Bureau of Educational Experiments was founded by Lucy Sprague Mitchell to study and document early childhood education. Two years later, the School for Children was opened, first as a nursery school. It later expanded to include an elementary school (the City and Country School) and the Cooperative School for Teachers. In 1950, Bank Street established a graduate program in education.

The Fleischman's Yeast building was the home of the Bank Street School between 1930 and 1950, when they moved uptown to their present location on West 112th Street. It was during its residence at 69 Bank Street in 1937 that the Writers Laboratory was founded to encourage children's book authors. A Division of Publications was established, numbering among its authors Maurice Sendak and our friend, Margaret Wise Brown,

whose interactive work with the small children at the school influenced her writing. Bank Street helped create the Little Golden Books, a very inexpensively produced—and extremely successful—series, which made children's books affordable to many more families than had previously been possible. Brown was one of the Little Golden Books authors.

In addition to playing a role in American literary history and the development of modern education, Bank Street figures prominently in the history of the American theater and motion pictures.

Right next door to the Bank Street College, on the corner of Bleecker Street, is the apartment house where Lauren Bacall lived with her mother in the early 1940s, 75 Bank Street. She was still called Betty Joan Perske when she became Miss Greenwich Village in 1942.

And two blocks from the Bank Street College of Education, between Greenwich and Washington Streets and across the street from the house where John Lennon and Yoko Ono lived between 1971 and 1973, is another famous school: HB Studio at 120 Bank Street.

75 Bank Street.

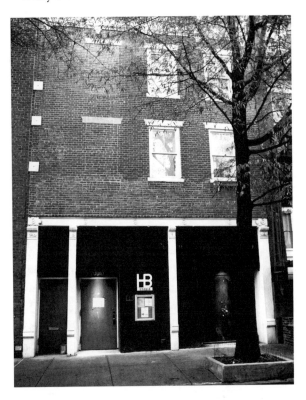

HB Studio, 120 Bank Street.

HB Studio has been around since 1945, when Herbert Berghof (1909–1990) established his theater school, the Herbert Berghof Studio. He was joined three years later by Uta Hagen (1919–2004), whom he married in 1957. Berghof and Hagen both had prominent acting and, in the case of Berghof, directing careers. Berghof is credited with staging the first American production of Samuel Beckett's *Waiting for Godot* in 1956, as well as Jean Cocteau's *Infernal Machine* two years later.

Hagen's stage career famously included the role of Desdemona, playing opposite Paul Robeson's Othello on Broadway in 1943–1944. Her association with Robeson won her a place on the Hollywood blacklist, which effectively kept her out of films. It also ended her marriage with Jose Ferrer, who played Iago in the same production. But her Broadway career garnered her three Tony Awards, including one for the role of Martha in Edward Albee's *Who's Afraid of Virginia Woolf* in 1963.

Since its inception, HB has provided professional education in acting, directing, playwriting, musical theater and related arts to generations of

renowned members of the theatrical community. It moved to 120 Bank Street from its original home in Chelsea in 1958, and here it remains. HB Studio has numbered among its students Anne Bancroft, Stockard Channing, Jack Lemmon, Marsha Mason, Bette Midler, Jason Robards, Al Pacino, Robert De Niro and dozens of others.

Diagonally across Washington Street, occupying an entire city block between Washington and West Streets, Bank and Bethune Streets, is Westbeth, in a group of buildings that was the home of Bell Telephone Laboratories from 1898 until 1966. We'll get back to Westbeth momentarily, but first let's consider Bell Labs, since it was here that some of the most astonishing advances in the history of broadcasting and cinema, among other scientific discoveries, had their genesis.

Located in a thirteen-building complex, Bell Labs was created in 1925. It was a consolidation of the research division of Western Electric and the engineering facility of AT&T. The bulk of the complex was designed by Cyrus Eidlitz, who also built the *New York Times* building in 1904, and built in 1896, though parts date back to 1861. Construction was completed between 1899 and 1925, and a few years later, in 1931, a large tunnel was cut through the buildings on Washington Street between Bank and Bethune Streets to accommodate the High Line New York Central Elevated Freight Railway. We'll have more to say about the High Line in Chapter 11.

As a research facility, Western Electric and later Bell Laboratories made enormous strides in the field of telecommunications. They are credited with the invention of the vacuum tube, the first public broadcasting system (used at President Warren G. Harding's inauguration in 1921) and major advances in telephone and radio technology. In 1927, the first successful television transmission, sending images of Secretary of Commerce Herbert Hoover from Washington, D.C., to New York, was accomplished, and a primitive form of color television was tested in 1929. One year later, the first binaural (stereo) recordings were made. And it was here that the transistor was invented, netting the scientists involved the Nobel Prize in Physics in 1956. A number of other Nobel Prizes have been awarded to Bell Laboratories researchers.

In addition, Bell Labs developed the first sound-on-disc film projector in 1923, bringing the age of the "talkies" one step closer. The sound-on-disc process coordinated sound recorded on twelve- to sixteen-inch phonograph records with the motion picture being projected. Warner

Brothers' hugely popular 1927 movie, *The Jazz Singer*, was a sound-on-disc production, using the Vitaphone process developed at Bell Labs, and purchased by Warner Brothers in 1925. Bell Labs housed the first fully equipped experimental film studio built expressly for the perfection of the talkies. This space is now used as an off-off-Broadway theater.

Vitaphone, incidentally, had its glory days between 1926 and 1930, during which time Warner Brothers used the process to make several feature-length films and more than two thousand short subjects. A disadvantage of the process, however, was that a small defect in the disc could affect the sound synchronization of the entire film, a problem that was difficult to remedy. When it functioned properly, however, it was considered miraculous. The story goes that Sam Warner, after seeing a short film at Bell Labs with a recorded twelve-piece orchestra, was so sure that there was live music that he looked behind the screen for the musicians. (This may be apocryphal, but it's a good story.)

In its heyday, Bell Laboratories' Manhattan facility was a world leader in sound communication innovations. By the end of the 1940s, much of Bell Labs' research facilities had been relocated to New Jersey, and in 1966, the building was vacated.

But not for long. With funding from the National Endowment for the Arts and the J.M. Kaplan Fund, the thirteen buildings that comprised Bell Labs were converted into Westbeth Artists Housing, 384 apartments and studios that were made available to artists in all fields (fine arts, music, dance, theater, film) at affordable prices.

Westbeth, as you may have guessed, gets its name from the streets surrounding it: *West* Street and *Beth*une Street (although Bank and Washington Streets are also part of its boundaries).

Opened in 1970, the industrial and laboratory complex was converted by architect Richard Meier. The exterior of the Bell Labs complex was kept largely intact, but a courtyard was added, giving residents access to the buildings, as well as providing light and air to those living there.

Westbeth was one of Meier's earliest commissions, completed while still in his mid-thirties, and one of the first important conversions of an industrial building to residences in the United States. Meier quickly achieved international fame and has had numerous important commissions worldwide, including the Getty Center in Los Angeles, the Museum of Contemporary Art in Barcelona and the Jubilee Church in Rome.

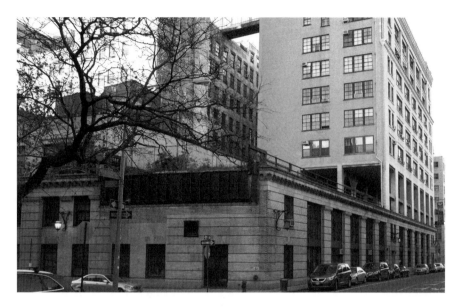

Westbeth Artists Housing, Bank and Washington Streets.

In the years following the opening of Westbeth, a number of other buildings in the West Village were built or redesigned by Richard Meier, including several in the neighborhood of the Palazzo Chupi, making an interesting contrast between Schnabel's bright pink neo-Renaissance construction and Meier's modern, mostly white, structures, which feature a lot of glass. Like the Palazzo Chupi, the apartments in Meier's buildings are way beyond the means of ordinary mortals. The celebrity owners' list is impressive. The residents of Westbeth mostly come from a different segment of the population.

Westbeth, in addition to housing hundreds of artists at all stages of their careers, serves the Greenwich Village community with various public spaces for film screenings, theatrical performances and art exhibitions. The buildings are on the New York State Register of Historic Places.

With Westbeth as a shining example, many other factories and warehouses in the United States have subsequently been converted for residential use. The waiting list for apartments in Westbeth, which at one time was years long, has been closed since 2007, but perhaps, sooner or later, spaces will once again be made available.

WEST STREET

*Superior Ink and Herman Melville, Gansevoort Market, the
Meatpacking District and the Death Avenue Cowboy*

L et's continue north along West Street, the far west border of the
Original West Village.

A block beyond Westbeth, at 469 West Street, between Bethune
and West Twelfth Streets, is the Superior Ink Building. The Superior
Ink Factory, which was located in the 1919 building formerly housing
the Nabisco Cracker Factory (once the world's largest bakery), was
transformed in 2010 into the Superior Ink Condos. "Transformed" is
not quite accurate; the former industrial building was sold in 2006 for
$41 million, demolished and rebuilt as a seventeen-story luxury condo
building despite the protests of Greenwich Village preservationists who
tried but failed to save the old factory building.

Connected to the building are seven recently erected townhouses on
Bethune Street, forming a complex of buildings that have attracted a
celebrity population and others willing to pay between $2 million and
$20 million to live there. The penthouse was listed in May 2010 for
$33.5 million. At this writing, most of the condos have been sold. In all
fairness, it should be mentioned that the construction has been praised as
an environmentally friendly development, with high standards of energy
efficiency, water conservation and sustainable building materials.

Not far from the Superior Ink Condos is a location steeped in history. It
was here, at 507 West Street, that novelist Herman Melville (1819–1891)
spent nineteen years, toward the end of his life, as a customs inspector.

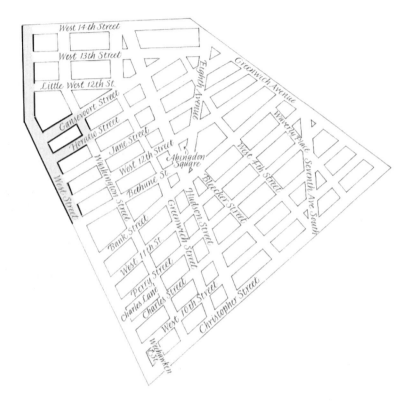

How did Melville, long considered one of America's foremost writers, end up as a customs inspector? Melville's life and his literary career followed a strange trajectory. Born in New York City, Melville was the grandson of General Peter Gansevoort, a hero of the American Revolution. Ironically, it was on the Gansevoort docks that Melville spent his last working years, but his illustrious ancestry did little to aid him in life.

Melville spent several years at sea. At nineteen, he became a cabin boy on a voyage to Liverpool and a couple of years later signed onto a whaling ship, the *Acushnet*. He spent eighteen months in the South Pacific but abandoned ship in 1842 in the Marquesa Islands, where he lived for a few weeks among the Typee natives, reputed to be cannibals.

His experiences in the Marquesas were the inspiration for Melville's first novel, *Typee*, published in 1846, which was an immediate bestseller. His second novel, *Omoo*, also based on his weeks with the Typees, was nearly as popular, but nothing he was to write thereafter met with either

Photograph of an etching of Herman Melville after a portrait by Joseph O. Eaton. *Courtesy of the Library of Congress.*

critical or financial success. Though he lived into his seventies, his literary career was essentially over before he was thirty.

Moby Dick, which is probably on the curriculum of every high school in America, not to mention every college American literature course, was not well received, nor did it sell well during Melville's lifetime. Considered too difficult, it was rejected by the general public, as well as by most of his contemporaries. It earned him a mere $556.37 in royalties. Published in 1851, the first edition of three thousand copies did not sell out during his lifetime. (Just think what a first edition of *Moby Dick* is worth today!)

Although he continued to write novels, short stories and poetry, Melville was unable to support himself and his family. After three years living on a farm in Massachusetts, where he wrote *Moby Dick* and the even less successful novel, *Pierre*, Melville brought his family back to New York, where he was to spend the rest of his life. His wife and her family pulled strings to get him a job as a New York customs inspector for the Department of Docks, which brought him to 507 West Street. The building has long since vanished, but it was located on the wharf at the end of Gansevoort Street, the very street that bears the name of Melville's famous grandfather.

It was during his years on Gansevoort docks that Melville started his last novel, *Billy Budd, Sailor*. Left unfinished at the time of his death, it wasn't published until 1924, but it is sometimes considered the literary equal of *Moby Dick*. In fact, it wasn't discovered until a revival of interest in Melville's work in the 1920s brought it to light. This interest has never slackened. His nineteen years on the docks of New York, however, are a little-known footnote to the history of the Original West Village.

Melville died in obscurity. An obituary, published in the *Press* on September 29, 1891, said, "If the truth were known, even his own generation has long thought him dead."

Gansevoort Street has lots of other stories. Before the name was changed to Gansevoort Street (in the early nineteenth century), it was called Great Kills Road because a large kiln was located nearby; "kiln" evolved into "Kills."

The street was later named for the fort that once stood here, Fort Gansevoort, which was named in honor of Herman Melville's granddad. (Actually, the fort was named for General Gansevoort; the street was named for the fort.) The fort was built in 1811, in anticipation of the War of 1812, to protect the New York harbor—unnecessarily, as it turned out. It was also called the White Fort because it was built of whitewashed stone. The fort disappeared in 1849, and oddly enough, its existence was apparently forgotten until 1949! We'll get back to that later.

After Fort Gansevoort was demolished, the site was occupied by three city markets, the Gansevoort Farmers' Market, the West Washington Market and, many years later, the Gansevoort Market Meat Center. The first of the three, the farmers' market, was in the planning stage for more than fifty years before it saw the light of day. In 1831, the city proposed the purchase of underwater property, owned by the Astor family, to be used as landfill for a new market. The market, according to an 1863 *New York Times* article (this was clearly a very long process), would "more fully accommodate the upper section of the City." It took until 1852 before the sale was completed and the land filled, creating the current waterline. But no market was built until the 1880s.

In 1854, the Hudson River Railroad opened a freight depot on Gansevoort Street, and shortly thereafter, pushcart vendors started to gather nearby, migrating north from the overcrowded downtown markets. This put them in a more advantageous spot for the produce arriving

in New York by ship and rail. The city finally opened the Gansevoort Farmers' Market officially in 1884. An open-air produce market, it was located right where Fort Gansevoort once stood.

Three years later, construction began on the West Washington Market, built to sell meat, poultry, and dairy products; it opened in 1889. The ten two-story brick buildings, with their backs to the Hudson River piers and their fronts facing West Street, effectively doubled the size of the existing market. The West Washington Market remained there for 65 years.

West Street was widened in 1954, and the West Washington Market was replaced by the Gansevoort Garbage Terminal. A Department of Sanitation incinerator, popularly called "the Gansevoort Destructor," was installed. This garbage processing plant is no longer in use, but the building is still used as a storehouse for the rock salt that is spread over New York City streets in winter.

A few years prior to this, in 1949, the Gansevoort Market Meat Center opened on the site of the original farmers' market. It was during the excavation of the site that the foundations of Fort Gansevoort were discovered, apparently to everyone's surprise.

By that time, meat had replaced produce as the main business of this part of the city. In fact, we currently call it the Meatpacking District, and it now extends from Gansevoort to Fourteenth Streets and from the Hudson River to Hudson Street. The Gansevoort Market Historic District, consisting of 104 buildings, is now protected by the New York City Landmarks Preservation Commission, and the entire Meatpacking District is on the New York State and National Registers of Historic Places.

A glance around the neighborhood will tell you that there isn't a lot of meatpacking going on these days. Although a few meatpackers remain, most of the 250 slaughterhouses and packing plants that existed here in 1900 have disappeared, giving way to up-market boutiques, restaurants, clubs and galleries. (For a decade or two, between the decline of meatpacking and the rise of the shopping/dining destinations, these streets were notorious for rough bars and sex clubs—remember the Anvil and the Mineshaft?—but these too have vanished.)

The buildings in these streets are among the most picturesque in the city, especially if your taste runs toward industrial and commercial architecture! Mid-nineteenth-century houses and early twentieth-

century warehouses share the streets with market buildings, most of which are low rise, often only two stories high. Many have corrugated metal awnings added in the 1940s, large ground-floor spaces, often with wide entrances designed to accommodate animal carcasses and second-floor office space. A number of five-story tenement buildings can still be found, although they have all been converted to high-priced residences. Streets paved with Belgian blocks complete the picture.

There are a few big buildings too, one of which is the former Gansevoort Pumping Station, built in 1910 to fight fires in the surrounding industrial area. The pump house boasted efficient high-pressure equipment. Forty years later, the building was converted to a cold storage meat warehouse, still partially in use today.

Another significant business was the Manhattan Refrigerating Company. It occupied the entire block between West and Washington Streets, Gansevoort and Horatio Streets, just south of the Gansevoort Farmers' Market. Incorporated in 1894, it consisted of a power plant and nine cold-storage warehouses (known as the Gansevoort Freezing and Cold Storage Company). The Manhattan Refrigerator Company was responsible for installing a system of underground iron pipes that carried refrigeration to all the meatpacking businesses in the West Washington Market. The company closed in 1979, and the West Coast Apartments—234 of them—were erected on the site.

Old facade of Manhattan Refrigerating Company (contemporary view).

The story goes that the Gansevoort Freezing and Cold Storage Company had been cold for so long that it took two months for the building to thaw before the conversion to apartments could begin!

With all the produce and meat arriving and leaving the various Gansevoort markets, the area quickly became a very busy transportation hub. Shipping was being shifted from the east side of the island to the west side because the Hudson's deeper ports could accommodate the steamboats that were beginning to replace sailing ships. More and more activity was taking place at the Hudson docks. The Hudson Railroad freight line developed in the 1850s when it became apparent that freight transportation would be more profitable than passenger service in this part of Manhattan.

The city had authorized street-level tracks to be installed in 1847, and by 1851, trains were running along the west side of Manhattan. The Hudson Railroad merged with the New York & Harlem Railroad in 1868 to form the New York Central Railroad. Freight trains ran from the Thirty-fourth Street terminal down the west side of Manhattan, carrying produce to the markets. Between the 1880s and 1929, steam locomotives pulled the trains along the ground-level tracks, right through the crowded Gansevoort open-air markets along West Street. This, not surprisingly, resulted in a number of fatal accidents.

In order to keep people off the tracks in this chaotic crush of pushcarts, vendors, wholesale shoppers and huge amounts of merchandise, the locomotives were led through traffic by a man on horseback carrying a red flag by day and a lantern at night. The fatalities along West Street (and its uptown extension, Tenth Avenue) won it the unfortunate nickname of "Death Avenue," and the men riding the horses were called "West Side Cowboys" and sometimes "Death Avenue Cowboys."

There's an interesting footnote to this tale. West Street wasn't the only Death Avenue in Manhattan, nor was it the first. Between the 1830s and 1860s, a stretch of Fourth Avenue (currently Park Avenue in the East Forties to Sixties) also had a steam locomotive running at street level. Because of numerous fatalities caused by that train line, Fourth Avenue was called the "Avenue of Death."

Great changes to the railroad came about in 1930. We'll learn more about that in the next chapter.

Let's take a quick look at an imposing building on the corner of West and Jane Streets, a couple of blocks south of the Meatpacking District. The address is 113 Jane Street.

This was once the American Seamen's Friend Society Institute, built by architect William A. Boring in 1907, who also designed some of Ellis Island's castlelike buildings. Built at a time when the port of New York was the busiest in the world, the American Seamen's Friend Society Institute was established to provide shelter and inexpensive housing for sailors, longshoremen and merchant seamen.

In 1908, the institute had 156 rooms for sailors at twenty-five cents a night. Other rooms—better quality, one assumes—were available for officers, cooks and engineers, who were charged fifty cents. The building originally housed a chapel, a concert hall and a bowling alley and shone a beacon lamp from its octagonal tower, visible up and down the Hudson. The tower remains, but the beacon is gone.

The funding for the institute is another New York tale. It was financed by Margaret Olivia Sage, widow of Wall Street financier Russell Sage who was nicknamed "the meanest man in New York." The story goes

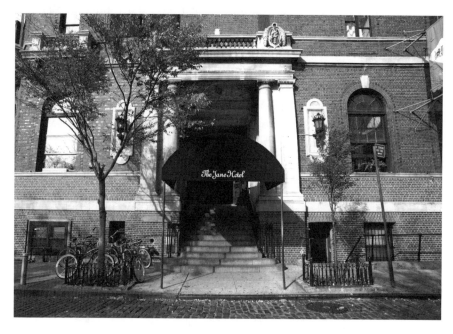

Jane Hotel, formerly American Seamen's Friend Society Institute.

that, one day, a deranged man burst into Russell Sage's office, which was located several floors up in a building adjacent to Trinity Church cemetery. Sage was sitting with his secretary and a client. Wielding a bomb, the man announced that he was going to blow up the meanest man in New York. Sage grabbed his secretary and used him as a shield. The bomb exploded, blowing the client out the window into Trinity Cemetery, severely injuring the secretary and leaving Sage unharmed. When Sage refused to pay his secretary's hospital bills, the secretary sued him and won a settlement.

At Russell Sage's death in 1906, his wife inherited $65 million and spent the rest of her life giving his money away. By the time she died in 1918, she had unloaded more than $85 million, which included the funding of the American Seamen's Friend Society Institute.

It was here that the survivors of the *Titanic* were brought to recuperate after the ship went down in 1912. The *Titanic* was intended to berth at the Cunard Pier on Fifteenth Street; instead the rescue ship, the *Carpathian*, delivered the surviving passengers to the institute.

The building went through several incarnations over the years. In 1944, it became a YMCA, and in subsequent years, it was used for SRO (single room occupancy) housing for the local indigent and homeless population during the neighborhood's dismal decades. Though said to be haunted by ghosts from the *Titanic*, the building is now a hotel.

UP ON THE HIGH LINE, DOWN ON HORATIO STREET

Odets, Baldwin, Pollock and the Hudson Dusters

The northwest corner of the Original West Village has become increasingly popular of late, not only because of the Meatpacking District and its fashionable shops and restaurants but also thanks to New York City's first elevated park, the High Line.

If you recall, the New York Central Railroad originally made its way through the busy streets of Manhattan, accompanied by the not always effective Death Avenue Cowboys. After nearly eighty years of deadly accidents, a decision was finally reached in 1929 to remove the street-level tracks from West Street and Tenth Avenue and build a new, safer elevated freight line thirty feet above ground level. This was part of the West Side Improvement Plan, a collaboration of New York City, New York State and the New York Central Railroad. The plan eliminated 105 street-level crossings and replaced the existing tracks with the High Line. The cost was estimated at $150 million.

The High Line was opened in 1934, connecting Manhattan's west side railroad yard at Thirty-fourth Street with St. John's Terminal, now the Holland Tunnel rotary, at Spring Street. This elevated freight line was built just east of the original tracks toward the middle of the block rather than along the avenues where the elevated passenger trains ran.

Trains passed right through some thirty existing buildings, including a number of large industrial buildings in the Meatpacking District, so goods could be loaded and unloaded indoors without disturbing street

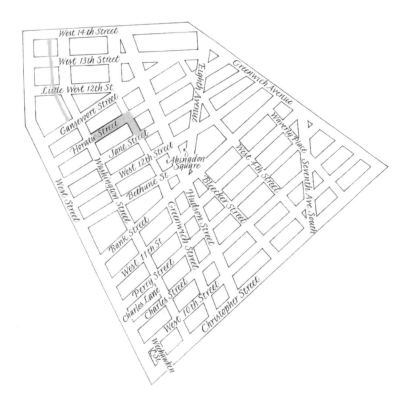

traffic. Special caissons were built for the trains to pass through Bell Labs in order to keep vibrations from affecting experiments.

Those were heady years for New York City transportation. The Holland Tunnel, connecting lower Manhattan with New Jersey, had opened in 1927, and the elevated Miller Highway, named after Julius Miller, Manhattan borough president between 1922 and 1930, and commonly known as the West Side Highway, was built a few years later, opening in 1931. (The Holland Tunnel is still there, but the West Side Highway was abandoned in 1973, after a car and a truck fell through the greatly deteriorated elevated roadway onto Fourteenth Street.)

Within twenty or twenty-five years of the opening of the High Line, however, the railroads were losing money. Trucks were replacing freight trains, and by the 1960s, the High Line was sufficiently underused that the southern section, below Gansevoort Street, was shut down. By 1980, the rest of the High Line was abandoned.

For nearly two decades, the High Line lay dormant, casting a shadow over the west side, annoying many local residents and being generally ignored by passersby. Plans were made and rejected for the demolition of the elevated structure, causing endless debate and arguments. But this time the preservationists won.

A nonprofit group called the Friends of the High Line, established in 1999, won community and city support in their battle to save the structure and transform it into a public space. In 2004, with the allocation of $50 million in city funding and the support of New York City mayor Michael Bloomberg, the High Line was given a new lease on life. Two years later, work started to remove the train tracks and restore and reconstruct it as a public park, the first such conversion in America. It was based on the model of the Promenade Plantée in Paris, built on an abandoned railway viaduct, which had been opened a few years previously.

The first section of the High Line Park opened in 2009, extending from Gansevoort Street to West Twentieth Street. Well-designed landscaping, incorporating the wild growth of plants that survived during its years as a derelict structure, combined with attractive pathways and seating, as well as its very unusual situation thirty feet above the sidewalks of New York,

The High Line, Gansevoort and Greenwich Streets.

have brought the crowds rushing in. Don't expect to enjoy an isolated stroll up here on a sunny summer afternoon.

The High Line, which is owned by the city (the structure was donated by the railroad company) and operated by the New York City Department of Parks and Recreation, remains under the watchful eye of the Friends of the High Line, which oversees maintenance and operations.

Let's climb back down to street level and see what else this corner of Manhattan can offer us.

A block south of the High Line is Horatio Street. Horatio Street was named for General Horatio Gates (1727–1806), another Revolutionary War hero. (One can't help wondering why it isn't called Gates Street.) A rather controversial figure, research seems to tell us that he "took credit" for defeating British general Burgoyne and winning the Battle of Saratoga, a rather wishy-washy accolade. He also led the American troops in the Battle of Camden (same war) in 1780, in which he was most definitely defeated by General Cornwallis. Anyway, the street we are on bears his name.

Leaving the waterfront behind us, we'll head east a block or two, and there on the two blocks between Washington and Hudson Streets, quite a few interesting figures and one notorious gang all took up residence during the twentieth century.

Starting at the corner of Washington Street, we come to 82 Horatio Street, the apartment building where Clifford Odets (1906–1963) lived from 1933 to 1935.

Odets's name is associated with one of New York's most important avant-garde theater companies, the Group Theatre, founded by Harold Clurman, Cheryl Crawford and Lee Strasberg in 1931. Left-wing and socially conscious, the Group Theatre produced Odets's first plays, all in 1935: *Waiting for Lefty*, which starred Elia Kazan; *Awake and Sing*; and *Till the Day I Die*, all of which addressed social and political problems of the Depression. *Awake and Sing* and *Till the Day I Die*, an anti-Nazi play, were on the same bill. They were probably all written while Odets lived on Horatio Street.

Odets's first three plays brought him international acclaim (and a lot of money), as did *Golden Boy*, also written for and produced by the Group Theatre. Starring Karl Malden, it played on Broadway in 1937. The

82 Horatio Street.

Group Theatre folded in 1941, but by that time, Odets had moved on to Hollywood, where he turned his talents to screenwriting.

A member of the American Communist Party in the mid-1930s, Odets was called before Senator McCarthy's House Un-American Activities Committee in 1953, where he provided testimony as a "friendly witness" (i.e., naming names). He managed to avoid being blacklisted. Odets went on to write one more play, *The Flowering Peach* (1954), and two screenplays, *The Sweet Smell of Success* (starring Burt Lancaster and Tony Curtis, 1957) and *Wild in the Country*, a 1961 Elvis Presley movie.

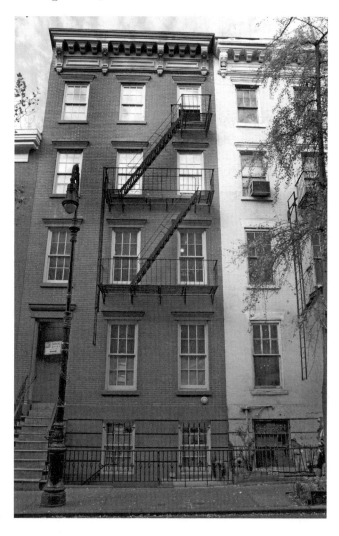

81 Horatio Street.

Right across the street from Odets, at 81 Horatio Street, is the apartment where James Baldwin lived in the 1960s.

James Baldwin (1924–1987), one of the most powerful voices of the American civil rights movement, moved from his birthplace in Harlem to Greenwich Village in the early 1940s. A prolific writer of novels, essays, poetry and plays, he divided his time between Europe and the United States, but it was here on Horatio Street that he wrote his novel *Another Country*, published in 1962.

A friend of Richard Wright, who was nearly twenty years his senior and a Greenwich Village neighbor, Baldwin's essay collections, *Notes of a Native Son*, published in 1955, and *Nobody Knows My Name: More Notes of a Native Son* (1961) borrow their titles from Wright's autobiographical novel. A bestseller, *Nobody Knows My Name* sold more than a million copies.

Baldwin, an active supporter and spokesman for civil rights, spent most of the '60s in New York City. He joined Martin Luther King in his 1963 March on Washington.

Largely autobiographical in content, Baldwin's novels concern not only civil rights and racial discrimination but homosexuality, a subject that was mostly taboo in the mid-twentieth century. *Giovanni's Room* (1954) and *Another Country* both dealt with homosexuality quite a few years before the topic was openly discussed.

In his obituary in the *New York Times* on December 2, 1987, it's noted that Baldwin didn't consider himself a spokesman for the civil rights movement, but one whose purpose it was to "bear witness to the truth."

Leaving the world of literary genius behind, let's walk a little farther along Horatio Street to the corner of Hudson Street for the lurid tale of one of New York's most famous street gangs.

The corner building, 633 Hudson, was the headquarters of the Hudson Dusters, which operated in the Village Waterfront neighborhood for about twenty-five years. It's not a very nice story, but it has its share of local color.

The Hudson Dusters were one of many Manhattan street gangs competing for territory in the late nineteenth and early twentieth centuries. Although there's no reliable documentation on the source of their name, it's been conjectured that the Hudson Dusters took their name from the slang word for cocaine, dust, which was a major preoccupation of many of the gang members—using it, not selling it. Essentially a bunch of drug-addicted thugs, they were responsible for numerous small acts of violence—muggings, waterfront theft and robbery of railroad depots—and spent much of their time fighting with other street gangs.

Mainly Irish American, the original leaders of the Hudson Dusters were known as Circular Jack, Kid Yorke and Goo Goo Knox.

Although they managed to drive most of the rival gangs from the Gansevoort docks, the Hudson Dusters met their match when they went

up against the tougher, more violent Hell's Kitchen gangs, notably the Gophers. Numbering five hundred strong, the Gophers controlled most of the waterfront north of Fourteenth Street.

The most notorious of the Gophers, probably because, unlike most gang members, he managed to live long enough to commit ever bigger crimes and acts of violence, was a man named Owen Madden, also known as Owney "the Killer" Madden. Leader of the Gophers and skilled with knife and lead pipe, Madden moved the Gophers into Hudson Duster territory in 1912 and managed to get himself shot eleven times as a result. Miraculously surviving, Madden refused to talk to the New York City police, but shortly thereafter, a number of members of the Dusters were shot to death.

Madden's murder of another Duster landed him in Sing Sing, but he emerged a few years later to pursue a career in bootlegging and organized crime. Madden later opened the very successful Cotton Club in Harlem (a "whites only" club that featured black entertainers), with partner and former gang rival Big Frenchy De Mange, and spent his sunset years in Hot Springs, Arkansas, where he died in his bed at the age of seventy-four.

But back to the Hudson Dusters: before their disappearance from the scene, their numbers reduced by death, drug overdoses, incarceration and the Gophers, they branched out into pushcart theft, extortion and election fraud, working for and protected by Tammany Hall.

By 1920, the Hudson Dusters were gone, but Greenwich Village gang activity continued. When Prohibition went into effect in 1920, New York City gangs directed their energy toward bootlegging, and gang membership shifted from mostly Irish American to Italian American.

Some years after the Hudson Dusters moved out (or died out), Jackson Pollock came to live at 47 Horatio Street. At the time, Pollock (1912–1956) was a young man, having recently arrived in New York from California. He signed up for classes at the Art Students League and studied with Thomas Hart Benton, and posed for him, for three years.

It wasn't until quite a few years later that Pollock's work achieved fame and notoriety. The most influential of the American abstract expressionists, Pollock's "drip technique" paintings—huge canvasses upon which Pollock would drip and splash house paints—were created

in the late '40s after the artist had left New York City. Also called his "all-over style," these paintings have no focal point but present the viewer with an overwhelming landscape of color, line and texture.

Although very controversial ("Is this art? My five-year-old kid....etc."), Pollock was a very successful artist, sponsored by Peggy Guggenheim and frequently argued about in the press. Collected by major museums (with very big walls), his work remains in great demand today. In 2006, his 1948 painting entitled *No. 5* was purchased by a private collector for $140 million, at the time the highest price ever paid for a painting. Pollock didn't live to witness this event; he died in an alcohol-related car crash at forty-four.

JANE STREET
AND BACK TO BANK STREET

Alexander Hamilton and Max Eastman, Auntie Mame and
Abingdon Square

W e are now standing on the corner of Jane Street, a block south of Horatio Street, between Washington and Greenwich Streets. Jane Street, by the way, may have got its name from a cow path that led to the tobacco farm owned by the Jayne or Jaynes family. It is thought that the spelling of the street name was changed by a local woman whose first name was Jane. This may well be conjecture, but in any case, there was no street at all when Alexander Hamilton died here in 1804.

This was the location of the Bayard Farm, founded before New Amsterdam became New York. The first of the family to settle in New Amsterdam, Nicholas Bayard (1644–1707) was either the son-in-law or the nephew of Peter Stuyvesant (or both). A wealthy Dutch merchant, Bayard owned two hundred acres of farmland in Manhattan and thousands more north of the city. He was Stuyvesant's private secretary and soon thereafter mayor of New York, rather briefly, from 1685 to 1686.

It was at the Bayard Farm that Hamilton died after his famous duel with Aaron Burr.

Hamilton, whom we all learned about in school, was one of the Founding Fathers of our country. A Revolutionary War hero and aide to General George Washington, he was the first secretary of the Treasury (under Washington), founder of the Bank of New York, and author, along with John Jay and James Madison, of the *Federalist Papers* (1788), urging the adoption of the United States Constitution.

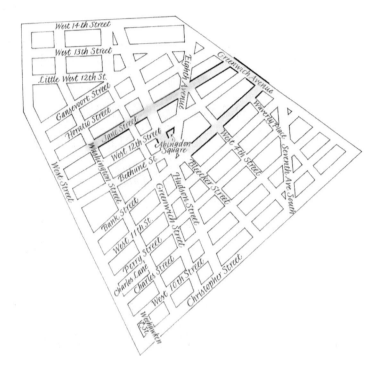

Hamilton and Burr were political opposites: Hamilton, representing the Federalists, calling for strong central government, and Burr a Jeffersonian Democrat. Burr, who had run unsuccessfully for president in 1800 and for governor of New York State in 1803, blamed Hamilton, perhaps rightly, for his losses. After escalating hostilities, both political and personal, Burr challenged Hamilton to a duel in 1804.

Hamilton accepted reluctantly, having recently lost his son in a similar confrontation, and the two men crossed the Hudson to Weehawken, New Jersey, to shoot at each other. Dueling, by the way, was illegal in New York, an offense punishable by death.

As they say, the rest is history. Mortally wounded by a bullet from Burr's gun, Hamilton was transported back across the river to the farmhouse of his friend William Bayard (descendant of Nicholas), where he died. There's a plaque on an apartment building at 82 Jane Street, commemorating this event, though neither the building nor the street existed in 1804.

Following Hamilton's death, Burr was indicted for murder, but the case never came to trial. Three years later, he was accused of

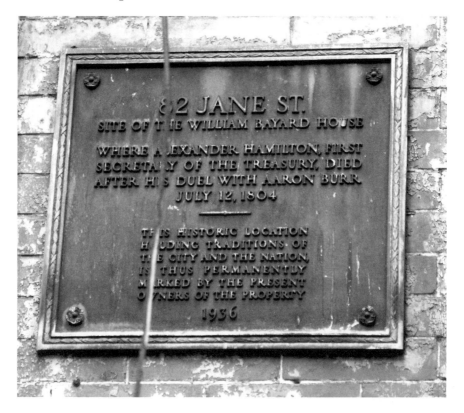

82 Jane Street, plaque commemorating Alexander Hamilton.

treason—the Burr Conspiracy; that's another story—and tried before the United States Supreme Court. He was acquitted, but his political career was over.

A block or so farther east, on the southwest corner of Hudson Street, was the Jane Street Garden, which had been here since the mid-1970s. The site was owned by the city but maintained by the West Village Committee. In 1982, an old-fashioned Dutch windmill was erected here, in commemoration of the 1782 Treaty of Amity and Commerce between the United States and the Netherlands. A princess in the Dutch royal family came to the commemoration ceremony, which took place at the Third Annual Jane Street Fair. The windmill did not survive very long; it burned down a few years later. The garden, however, was once full of flowering trees.

Although we are almost at Abingdon Square, the climax of our walk through the Original West Village, we're going to bypass it for the moment and head for Greenwich Avenue, the eastern border of the district. Greenwich Avenue, incidentally, was known as Greenwich Lane until 1843. It was originally an Indian path, one of five that crossed the forest that was to become Greenwich Village. The path, now an avenue, has been here for more than 350 years.

The building at 91 Greenwich Avenue, between West Twelfth and Bank Streets, was the home of the socialist periodical the *Masses* between 1913 and 1917. Edited by Max Eastman (1883–1969), the *Masses* published news commentary, fiction and poetry by, among others, Carl Sandburg, John Reed, Upton Sinclair, Sherwood Anderson and Louis Untermeyer. Among the artists who worked for the *Masses* were John Sloan, George Bellows and Robert Henri.

Strongly opposed to capitalism and militarism, the *Masses* ran into serious difficulties for publishing articles against United States involvement in World War I. In fact, Eastman and Reed were arrested and tried for sedition under the 1917 Espionage Act, which made it a crime to publish material undermining the war effort. They were both acquitted, but the *Masses* folded in 1918.

Reed went on to become one of the founders of the Communist Party of the United States, but Eastman's politics moved in the opposite direction. After an eye-opening trip to the Soviet Union in 1922, during which he became aware of the grim reality of Stalinism, Eastman wrote two books condemning the Soviet system: *Since Lenin Died* (1925) and *Marx and Lenin: the Science of Revolution* (1926). This resulted in his rejection by the American Communist Party.

By the beginning of World War II, Eastman had moved far enough to the right to publish antisocialist articles in *Reader's Digest* and the *National Review*, and by the 1950s, he was firmly in the camp of Senator McCarthy and a supporter of the actions of the House Un-American Activities Committee. He had traveled quite a distance from 91 Greenwich Avenue.

A block from the home of the *Masses*, at 22 Bank Street (corner of Waverly Place) we find ourselves in front of the Waverly Inn, actually *Ye* Waverly Inn. Built in 1844, the building was first used as a stable and then turned

into a tavern and (rumor has it) a bordello, before becoming a teahouse in 1920, patronized by the likes of Robert Frost and Edna St. Vincent Millay. In more recent years, there have been rumors of ghosts haunting the old building, to say nothing of celebrities who have recently "discovered" it.

One final stop—and a quintessentially Village locale—is near the corner of Bank and Bleecker Streets, the onetime home of Auntie Mame. Well, not exactly. Auntie Mame was a fictional character based on a real woman, Marion Tanner, who bought the house at 72 Bank Street in 1927 and lived here until she was evicted in 1964 for not paying her mortgage.

During her years in residence on Bank Street, Miss Tanner's home was a haven and salon for writers, radicals, free thinkers and, ultimately,

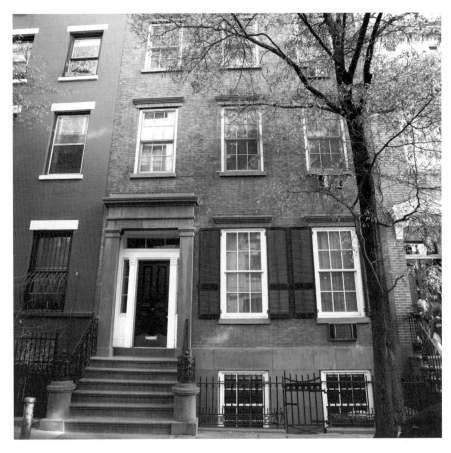

72 Bank Street.

for the homeless and displaced. She considered herself and her guests "Bohemians," an early use of the word to describe what were also known as "Greenwich Village types."

Tanner's nephew, Edward Everett Tanner III, created the character Auntie Mame in his enormously successful novel of the same name, written under the pseudonym Patrick Dennis. The book was published in 1955. In later years, Tanner III denied that his aunt was the inspiration for the irrepressible character who raised her nephew and "forgot" to send him to school. In fact, Miss Tanner wasn't all that happy with the characterization either, though she dined out on it for decades. (The real nephew, Edward Everett Tanner III, actually lived with his parents and did, in fact, go to school.)

The novel was a bestseller and took on a life of its own. After selling two million copies, the book was turned into a successful Broadway play in 1957, starring Rosalind Russell, and later Bea Lillie, as Mame. From there it went to Hollywood and made more money than any other film of 1959. Seven years later, it was back on Broadway, this time as a musical,

Village Nursing Home, West Twelfth and Hudson Streets.

Mame, starring Angela Landsbury; and then another film was made, this time based on the musical, with Lucille Ball playing the lead.

Tanner III—who was also, at one time, the butler of Ray Kroc, founder of the McDonald's empire—died in 1976 estranged from his aunt, who outlived him by nine years. Marion Tanner spent the last years of her life in the Village Nursing Home, at 607 Hudson Street, right down the street from where her Bohemian salon had once flourished.

Standing in front of what was once Marion Tanner's home, we can see Abingdon Square, a very small park with a very long history.

Remember our old friend, Sir Peter Warren? We're standing on his land and have been, pretty much the whole time we've been wandering around the Original West Village.

In 1768, Sir Peter's eldest daughter, Charlotte, married Willoughby Bertie, the fourth Earl of Abingdon. (He was, incidentally, a composer and music patron, friend of both Joseph Haydn and Johann Christian Bach.) Charlotte's dowry included the land that is now called Abingdon Square. In fact, the name Abingdon survived the sweeping changes in New York street names that took place a few years after the American Revolution. In 1794, most city streets and roads with British names were renamed, but Abingdon Square was spared. The earl and Charlotte, it seems, had supported the American side during the Revolutionary War. Another street that was named after the earl, however, did not fare as well: Abingdon Lane, also known as Love Lane, which ran from east to west across Manhattan where Twenty-first Street is currently located, disappeared when the Manhattan grid went into effect circa 1800.

In case you are interested, there have been a number of other Earls of Abingdon since Bertie's day; the current earl is number nine.

Abingdon Square, which is bounded on the north by Twelfth Street, south by Bank Street, east by Bleecker Street and Eighth Avenue and west by Hudson Street, has been a New York City park since the 1830s. It was acquired by the city in 1831, at which time $3,000 was allocated to create a park, which opened five years later.

A very small park indeed, Abingdon Square measures exactly 0.222 acres, according to the New York City Parks Department website. In the center of the square (which is actually a triangle) is a life-size bronze statue of a World War I soldier, officially known as the Abingdon Square

Abingdon Square today.

Abingdon Square today.

Memorial, but popularly called the "Abingdon Doughboy." The memorial was a gift of the Jefferson Democratic Club, who had their headquarters on West Twelfth Street, across from Abingdon Square.

Created by Philip Martiny, a well-known sculptor in his day, the doughboy was dedicated in 1921 in memory of all the local soldiers who lost their lives during the First World War.

Alfred E. Smith, who at the time was the former *and* future governor of New York State, unveiled the memorial before a crowd of twenty thousand, among who were two hundred Gold Star Mothers, whose sons had died in the war. Martiny, who was responsible for many New York City public sculptures, created a similar statue that stands on Twenty-eighth Street and Ninth Avenue, known as the "Chelsea Doughboy." If he looks familiar, it's because Martiny used the same model for both statues. The one in Abingdon Square, however, is notable for the flag that swirls around the figure, which seems about to be completely enveloped in its folds.

Today this little park has winding paths, perennial flowerbeds and a Saturday Greenmarket. The square was completely renovated in 2004, and the doughboy was moved from the northern end of the park to the southern end. It is curious to think that Sir Peter Warren's three-hundred-acre estate is memorialized in this pleasant little park that occupies one-fifth of an acre!

And that brings us back to where we started, historically if not geographically. When Sir Peter decided to make his home here in 1733, he helped make the future Greenwich Village fashionable. The fortunes of the Original West Village have gone up and down in the nearly 280 years since then, from rich to poor and back again, with the famous and infamous occupying these streets often at the same time. But the Village has endured and will, one hopes, retain its individuality and idiosyncratic character for a long time to come.

About the Authors

Alfred Pommer of New York City is a self-employed licensed New York City guide. He has been giving private and publicly scheduled neighborhood walking tours for groups or individuals in Manhattan's many diverse neighborhoods for over twenty years. During that time, Alfred has been constantly researching and improving each tour. He retired in 1991 after twenty-five years' service with the New York City Parks Department. During that time, he attended college part time, eventually graduating with a degree in labor studies. Alfred has had several articles about the history of various locations, streets and neighborhoods in Manhattan published by *10003 Magazine*.

A native of Brooklyn, New York, Eleanor Winters has been exploring New York City on foot for several decades. A commercial and fine artist specializing in calligraphy, she has written five books for calligraphers, all of which are currently in print: *Mastering Copperplate Calligraphy* (3rd ed., Dover Publications, 2001), *Calligraphy in Ten Easy Lessons* with Laurie Lico (2nd ed., Dover

Publications, 2003), *Calligraphy for Kids* (Sterling Publishing, 2004), *1-2-3 Calligraphy* (Sterling Publishing, 2006) and *Italic and Copperplate Calligraphy: The Basics and Beyond* (Dover Publications, 2011). She also served as editor of *The Calligrapher's Engagement Calendar* from 1979 to 2005. Eleanor lives half the year in Brooklyn and half in Paris and teaches calligraphy to beginners as well as professionals in Europe and the United States. She exhibits her artwork widely and is represented by the Franklin 54 Gallery + Projects in Manhattan. Eleanor has a master's of art from New York University.